Yad Vashem

Moshe Safdie—The Architecture of Memory

Joan Ockman

Moshe Safdie

Avner Shalev

Elie Wiesel

*Moshe Safdie*

*May 8*

*2010*

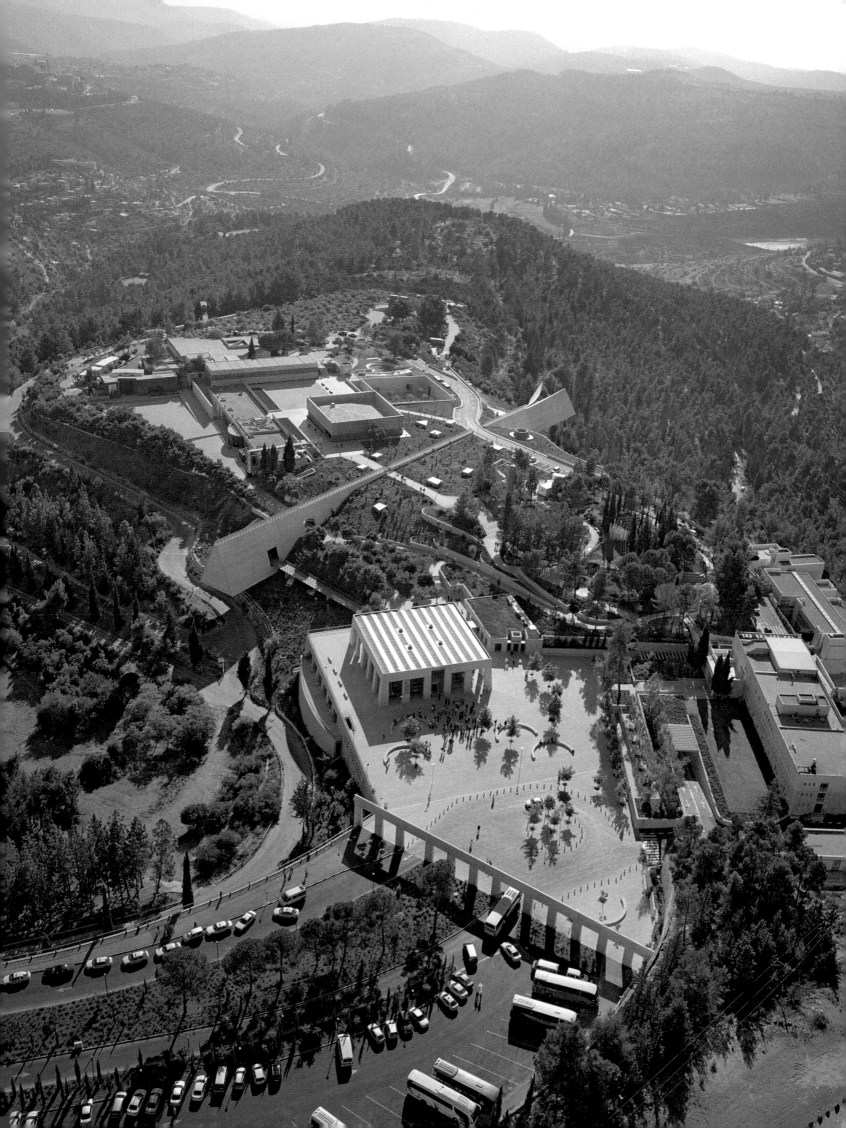

# YAD VASHEM

## MOSHE SAFDIE–
## THE ARCHITECTURE
## OF MEMORY

LARS MÜLLER PUBLISHERS

" I WILL PUT MY BREATH INT

מוקדש לניצולים, נושאי הזיכרון בחייהם
DEDICATED TO THE SURVIVORS,
O THROUGH THEIR LIVES BEAR THE MEMORY
געווידמעט די לעבן-געבליבענע פון דער שואה,
וואָס טראָגן דעם אָנדענק אין זייער לעבן
LOS RESKÁPADOS KE YEVAN EL RECORDO EN SUS VIDAS

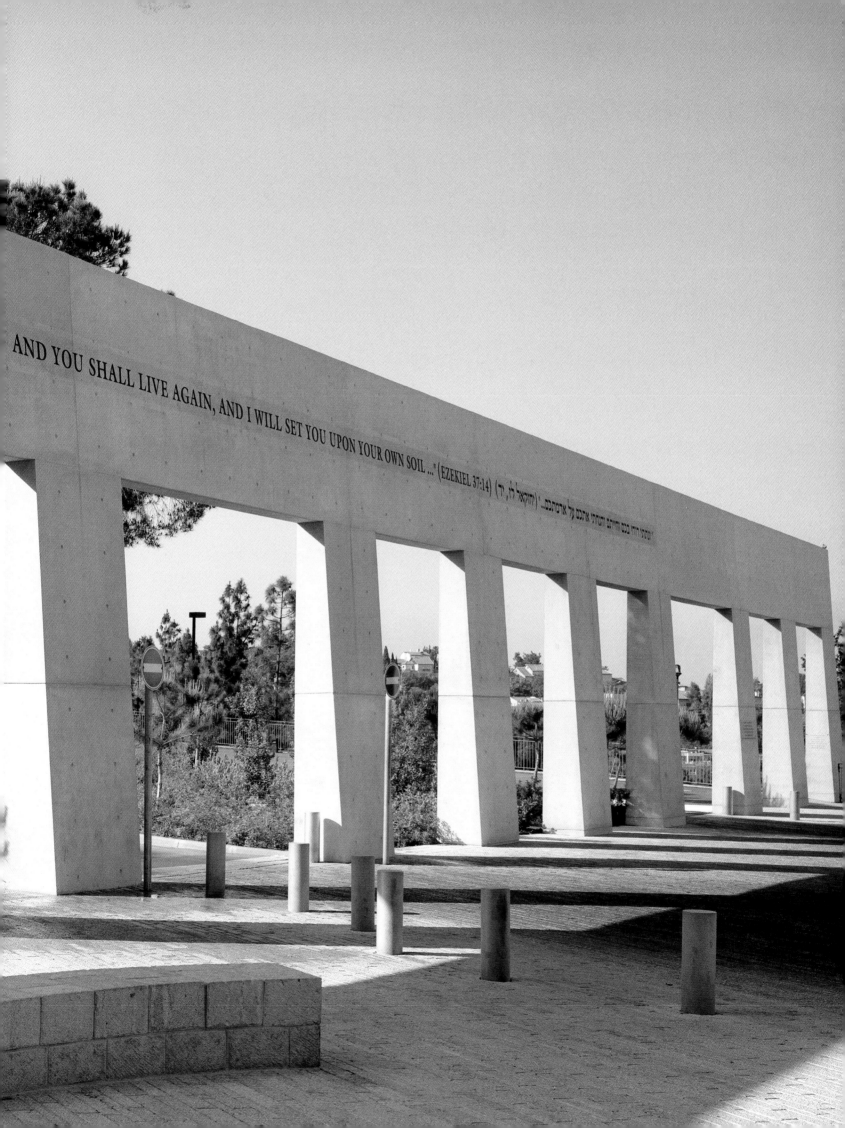

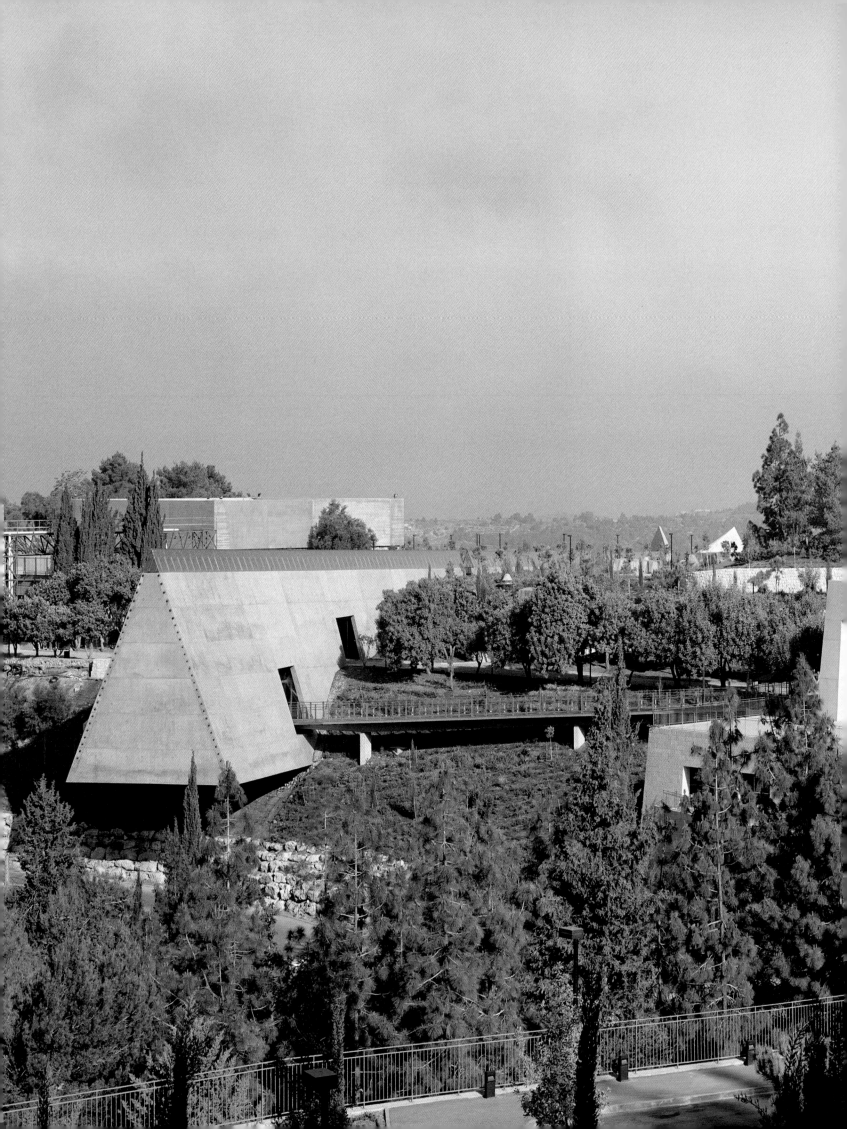

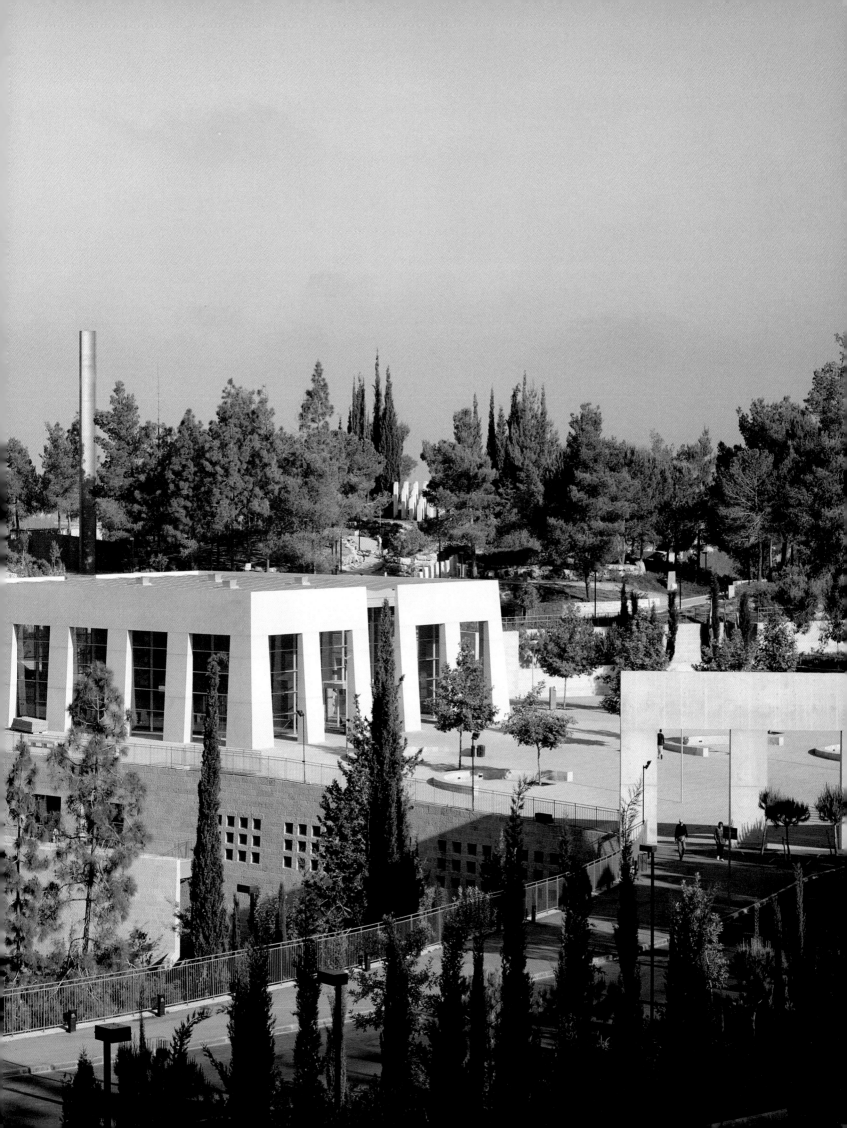

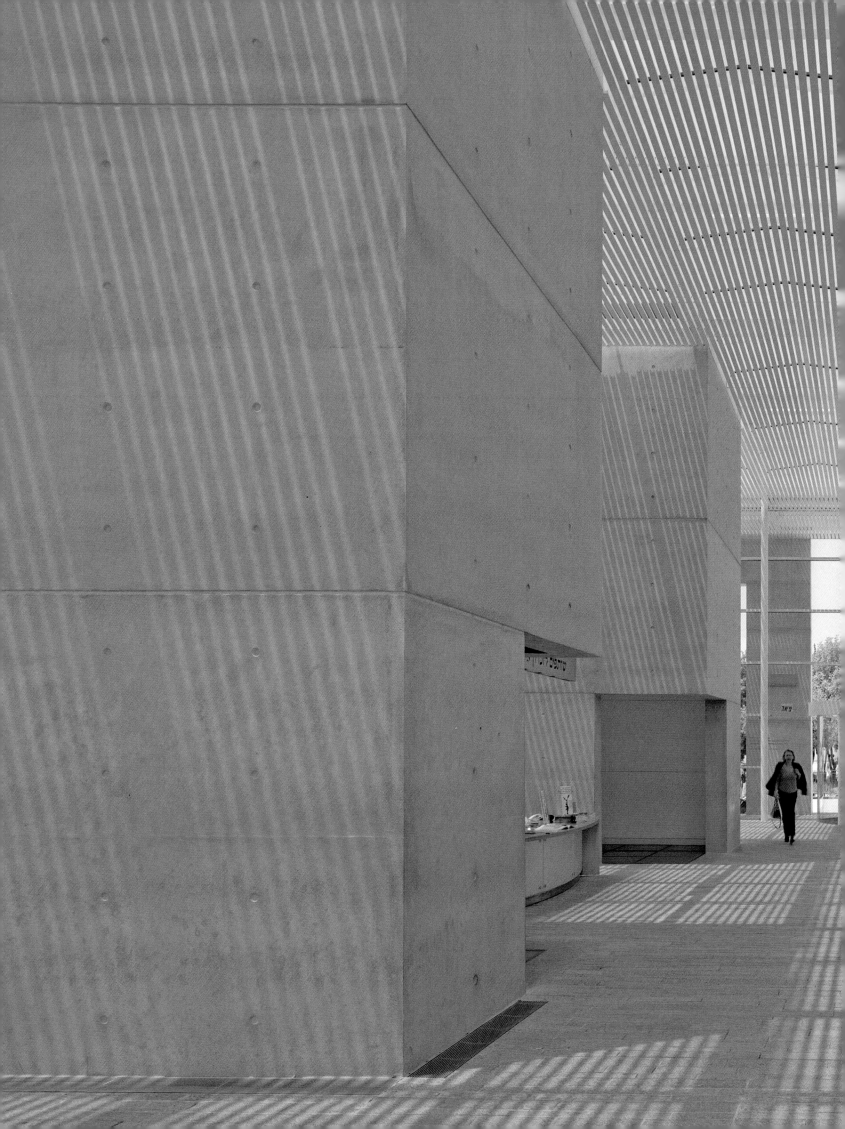

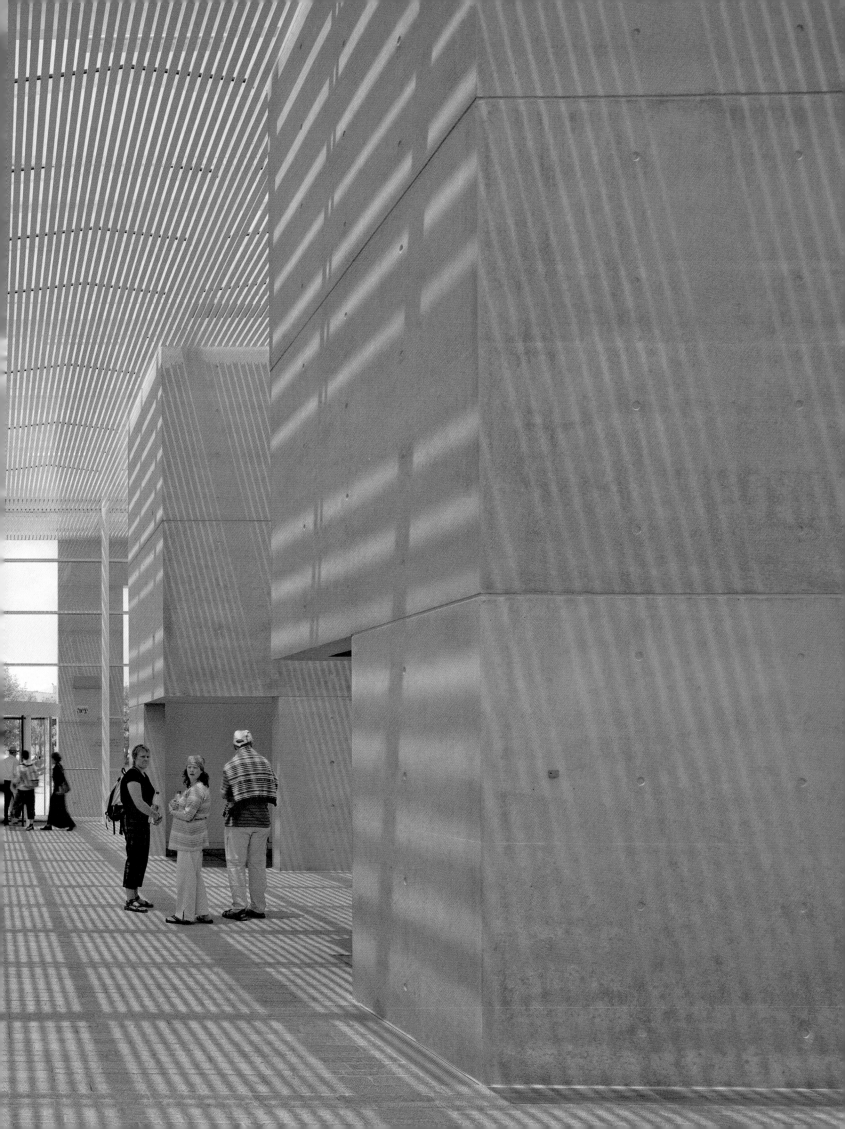

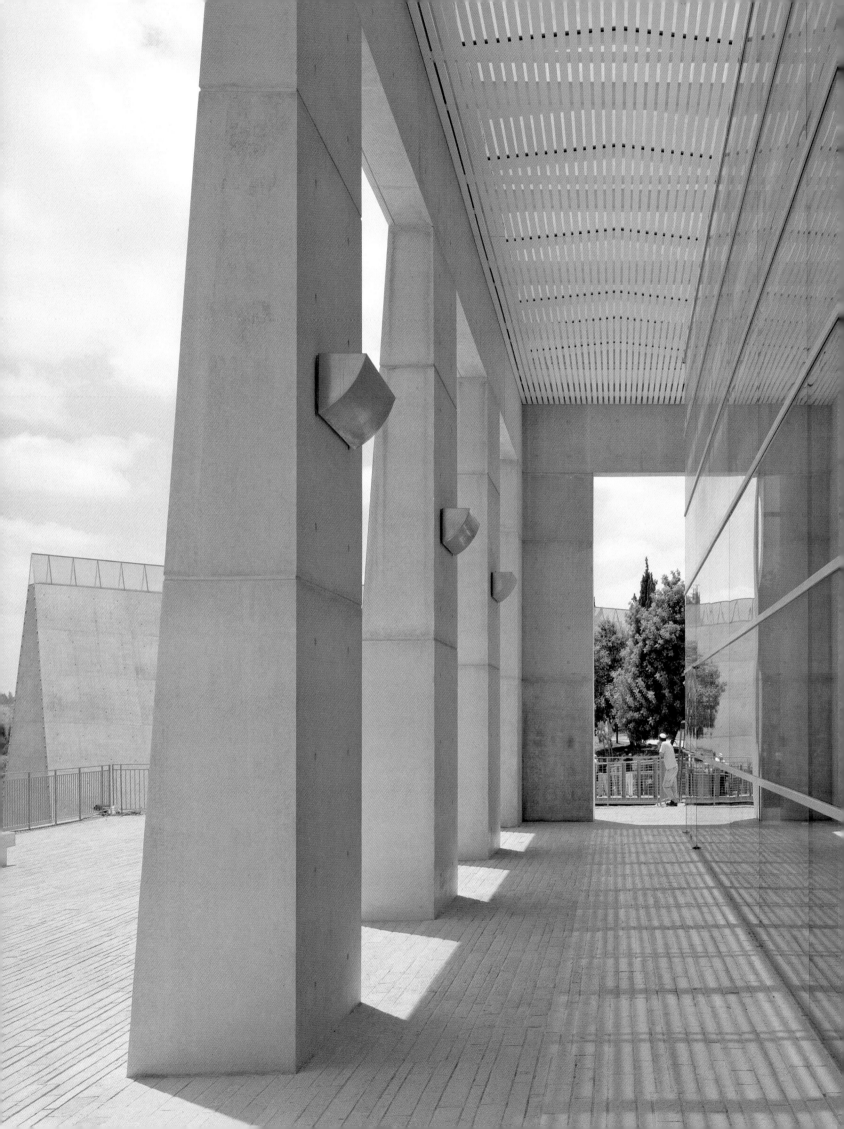

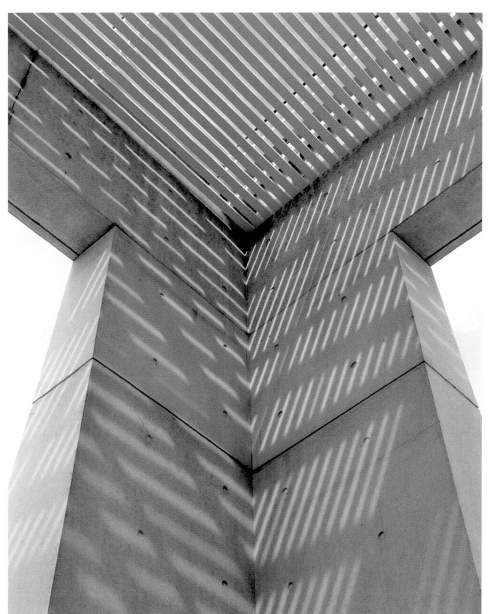

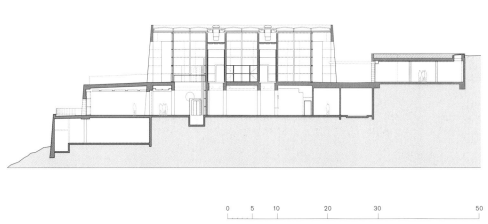

0　5　10　　　20　　　30　　　　　　50

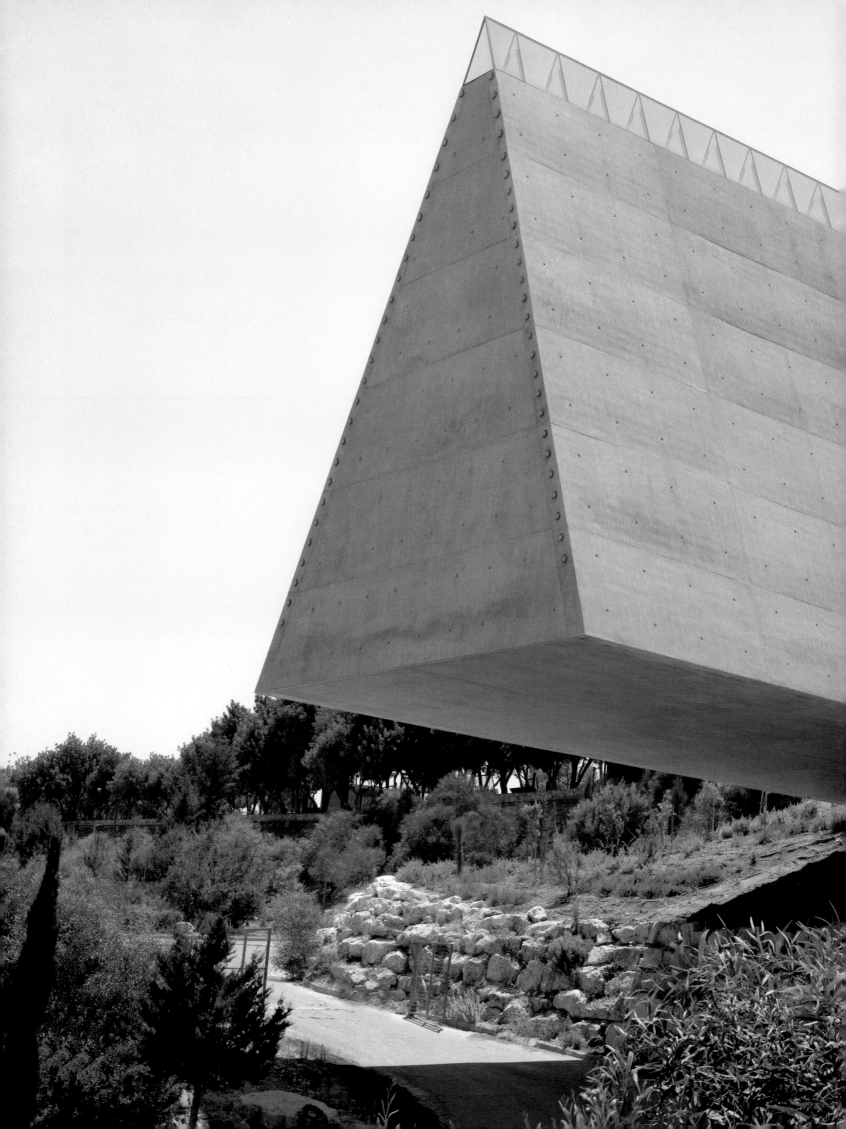

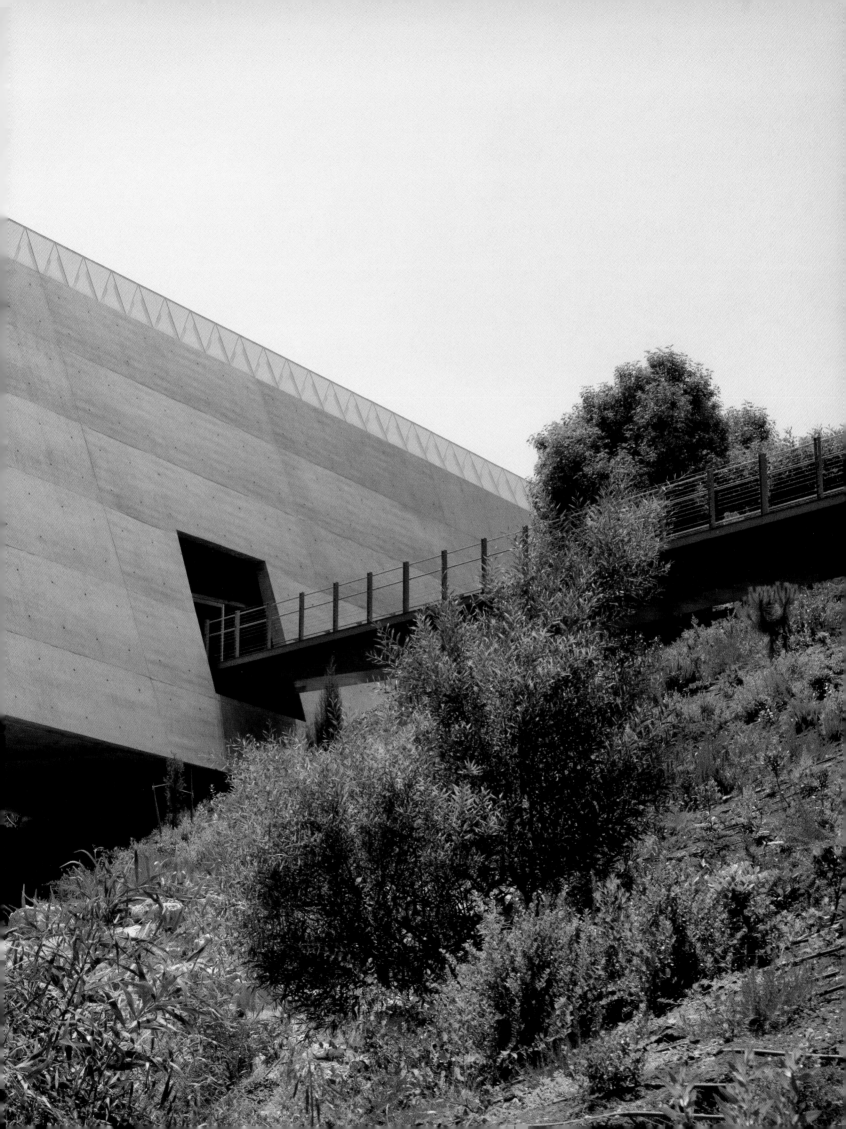

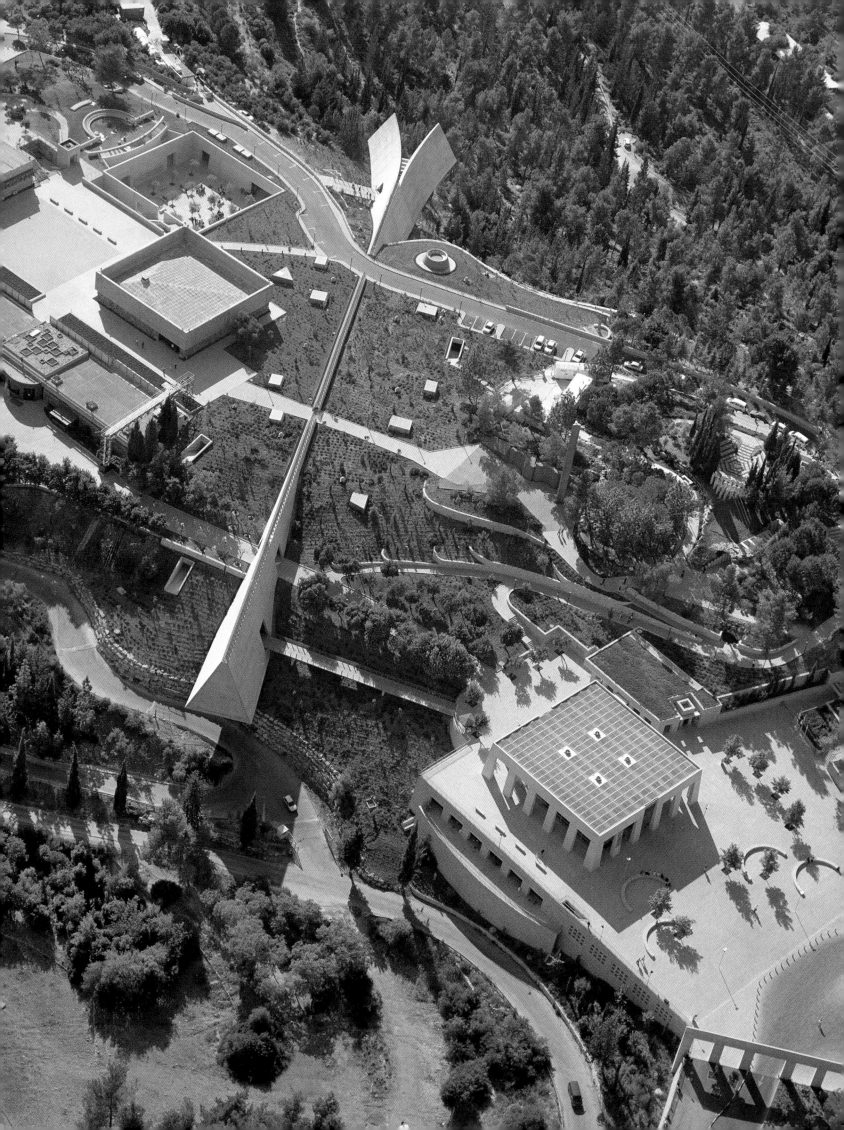

# A Place in the World for a World Displaced

Joan Ockman

The road winds from the biblical ramparts of Jerusalem's Old City out through the elegant modern neighborhoods of Talbiyeh and Rehavia, past the sprawling campuses of museum, government, and educational institutions at Givat Ram, and along clusters of terraced housing, recent high-rises, and rock-strewn hillsides. After about four miles a signpost points to the right. The trip ends at a security checkpoint, an allée of cypress and carob trees, a gaggle of tour buses and taxis, and then a concrete screen wall that is anchored at either end into tiered stone abutments and rises out of the cascading landscape to silhouette the blue Israeli sky: "Yad Vashem," a memorial place and a name.

The Holocaust Martyrs' and Heroes' Remembrance Authority was established in 1953 by a law that set up a central institution dedicated to the study and commemoration of Jewish annihilation at the hands of the Nazis and mandated its location in Jerusalem. Also known as Har Hazikaron (Mount of Remembrance), Yad Vashem's four-acre site is located on the western slopes of Mount Herzl, a hill that houses Jerusalem's military cemetery as well as the national cemetery where Israeli leaders are laid to rest. In 1957 a first building opened with administration, archive, and library facilities, followed in 1961 by the ceremonial Hall of Remembrance and a basic exhibit. A museum containing a more permanent exhibition was inaugurated in 1973, and over the years a series of institutional spaces and memorials, gardens, and artworks were added. Among these were two small, dramatic structures designed by Moshe Safdie: the Children's Holocaust Memorial, completed in 1987, and the Memorial to the Deportees, in 1995. By the beginning of the 1990s the main exhibition building had proved inadequate to the demands of current technology and tourism, and a phased redevelopment of the site was launched. This culminated in spring of 2005 with the inauguration of a major new centerpiece, a museum of Holocaust history and ancillary structures, also designed by Moshe Safdie and Associates.

The verticals of the pristinely articulated screen wall marking the threshold of Yad Vashem's commemorative precinct widen at the base and cant back a few degrees. Evoking Karnak at a less monumental scale, they sound the opening notes of a spatial composition that is both symphonic and at times vertiginous, belying its deceptively simple geometry. A broad stone plaza fans forty-five degrees in deference to the topography. Ahead sits a square pavilion edged on four sides with similar screen walls, parted bilaterally for entry. This porous structure, the *mevoah*, contains reception and information facilities. Its aluminum-trellis roof striates the floor with strong shadows, offering a rather dizzying orientation. Emerging from its far side onto a semi-circular platform, the visitor beholds a sharp, linear gash in the hilltop running perpendicular to the ridge and protruding at either end: the museum. One pauses to take a deep breath before traversing a delicate wood-and-steel bridge that plunges into its gaping concrete mouth.

Here commences a harrowing but unapologetically affirmative journey that recounts the history of the Holocaust from its origins in the vibrant, culturally rich Jewish communities of Europe through to its grand finale—not in the "solution" of the Nazi death camps, as at places of Holocaust memorialization in Europe and the United States, but rather in a redemptive and triumphal Zionist "homecoming," emotionally evoked by a recording from the 1930s of a children's choir from Mukacevo, then a part of Czechoslovakia, singing "Hatikva" (The Hope), which would become the Israeli national anthem. Accompanied by their welling voices, the visitor exits the gloom of the subterranean passageway to an expansive sunlit balcony. From here one overlooks a young forest of pine trees, the village of Beit Zait, and a distant horizon of hills and plains dotted as far as the eye can see with evidence of human habitation.

The path that leads to this climax is clear-cut but convoluted. While its terminus remains visible from one end of the hall to the other, illuminated by a running skylight above, it is reached physically only by a zigzag route. Just as the architect had the grace to separate the reception pavilion from the museum proper, he also turns the visitor abruptly to the left upon entering. The gesture not only arrests the visitor's steps for a moment before setting him on the circulation route to the right, but creates a direct confrontation with the museum's south face, an extruded and vertically compressed fifty-foot-high triangle. This figure establishes the leitmotif of the building. It also serves as a projection wall for a filmic montage, created by the artist Michal Rovner, that draws on fragmentary archival footage depicting Jewish life prior to the Nazi persecution. From here the visitor turns another 180 degrees before proceeding down a ramp to immerse himself in a chronologically and thematically arranged trajectory.

Safdie has described the eureka moment when, reluctant to place the building crownlike on top of the hill, he thought of tunneling through the ground. The diagonal flanks of the cast-concrete structure are post-tensioned with steel reinforcement to support the compressive load of the hill, while the glazed vertex of the building's triangular section protrudes through the earth, allowing light to filter down to the circulation spine. From outside, the architect's act of violence in slitting open the ground is felt viscerally, expressing itself as an archaeological scar symbolically healed by the landscape itself. Inside, along the nearly six-hundred-foot length of the tunnel, the already compressed triangular geometry is likewise visceral, constricting to its narrowest diameter at one of the darkest points in the curatorial narrative—the extermination of more than 1.1 million Jews at Auschwitz-Birkenau—before eventually widening to a generous equilateral conclusion. In tandem with this modulation in the building's longitudinal section, the floor and roof planes also ramp five degrees downward and then back up, producing a perspectival

distortion that destabilizes the visitor's sense of equilibrium and creates a haptic sense of down and up, dark and light, contraction and expansion, weight and suspension.

At the same time, exhibition galleries of varying sizes and shapes, carved out like high caverns, are strung along either side of the axis. Some are illuminated by sculpturally shaped *canons lumières*. Shallow angular trenches gouged in the floor of the tunnel force the visitor to the right or left, creating a switchback path of movement from gallery to gallery. The trenches, also used to display artifacts and documentary material, are roped off with steel cables (a device that might have been treated more architectonically). In contrast to the rawness and minimalism of the concrete envelope, the exhibits, designed by Dorit Harel in association with the chairman of the Yad Vashem Directorate, Avner Shalev, make use of a rich variety of display techniques and media. The galleries are dense with objects, video monitors, text panels, and faithfully re-created environments and, on a typical day, bottlenecked with groups being shepherded through the warrens of ingeniously partitioned alcoves by tour guides speaking many languages. Israeli soldiers rub elbows with Orthodox Jews and Filipino nuns, high school students with elderly visitors moving their folding stools from space to space listening to earphones. The objects and personal testimonials are poignant and wrenching, and if the teleological undertow of martyrdom, heroic resistance, and survival propels one to the dénouement at the tunnel's end, the installation errs on the side of measured presentation and thoughtful commentary rather than theatricality. A teenager pulls his friend over to a panel titled "Why didn't they bomb Auschwitz?" and says, "Here's what we were talking about before."

Within Safdie's architectural oeuvre, including his extensive body of work in Israel, the museum for Yad Vashem remains as exceptional as its extraordinary program. For one thing, his recent buildings, especially in a place as historically

and archaeologically layered as Jerusalem, have relied heavily on contextual references—arches and yellow limestone, for example—albeit abstracted into his own modern language. At Yad Vashem, however, the architecture calls the very idea of context into question. Since the diasporic experience of the Holocaust is not about place but rather displacement (up until its Zionist "return"), Safdie's decision to construct the museum in the alien, industrial material of concrete rather than in the prescribed Jerusalem limestone—a decision for which he had to get special permission from the municipal building authorities—has particular resonance.

The minimalist, organic forms at Yad Vashem are likewise largely unprecedented in Safdie's work. Maya Lin's excavation of the ground plane at the Vietnam Veterans Memorial in Washington, D.C., may have served as subliminal inspiration, as may have the warped surfaces of Richard Serra's *Tilted Arc* sculptures or earthworks by other recent artists. The triangular geometries employed by Frank Lloyd Wright—including his Beth Sholom Synagogue in Elkins Park, Pennsylvania—and by Louis Kahn may also have figured remotely. But Safdie's expressive use of the triangle here, closer to the psychic ambiance of German Expressionism although more serene and controlled, produces a whole Rorschach of other associations. The three-sided figure morphs in the viewer's imagination from primitive shelter or tent, to half-star of David, to fir tree, to an ark filled with survivors, to, more ominously, the pitched roof of a train shed full of deportees or a gas chamber at Treblinka. The cathartic opening at the end of the processional conjures up the biblical tabernacle, a pair of wings, the exultant blast of a horn or trumpet. Nor do the gray concrete surfaces fail to segue into vistas of sky and clouds on an overcast day, or merge with the faded photos, newspapers, and diary pages on display, or with the brittle fragments of Torah parchment in a vitrine; with its somber and sparing use of color, the museum's interior evokes a world that it is only possible to recall "in black and white." At the same time, the super-

abundant play of metaphor unleashed by the abstract architecture sets up an opposition between the freedom of imagination—something that sustained so many of the Holocaust victims even in the most dire circumstances— and the non-freedom of facts, lists, maps, statistics, newsreels, body counts.

We are, to be sure, dealing with two distinct modes of representation, each of which meets its absolute limit at Yad Vashem. One is historical, documentary, and narrative; the other is aesthetic and spatial. It is the difference, precisely, between a name and a physical memorial, a name and a place. If the curatorial mission at Yad Vashem is to name the names of those who perished in the Holocaust, even as it is the fate of so many to remain nameless, then the architectural mission is to establish a place, however paradoxically it is to be a place of displacement. There is no way, of course, to provide closure or resolution to a trauma like the Holocaust, and the purpose of a consecrated site like Yad Vashem is precisely to keep the memory of the Holocaust painfully alive rather than allow it to pass into history. Yet the historian or "memorian" strives to provide an account of the past that relates discrete facts, events, and reminiscences, scrupulously collected, to a larger explanatory structure. The work of art, by contrast—more specifically here, of architecture—aspires beyond its sheer functional obligations to produce an empathic identification or unmediated apprehension of something ineffable, something that cannot be represented —an aesthetic experience, following Kant, comparable to that of the sublime.

Memory, we may say, is the shell of that which was once a body, a form of disembodied thought or reflection. Architecture, however, is a container, a shelter, a prosthetic device, a sarcophagus—in short, a form of embodiment. Safdie's bodily architecture attempts literally to bear witness, to produce a sense of gravity. But while in the hands of another architect such strong architectonic form-making might overwhelm the museum's equally potent yet more fragile content—as attested by a number of spectacular but unsuccessful recent

museum designs by contemporary architects—Safdie holds these impulses in check. One of the rare instances where scenography overtakes the function of simple and eloquent presentation and facts coexist uneasily with artifice is in the penultimate gallery, the Hall of Names. Here a cable-suspended zinc-clad dome overhangs a deep reflecting pool ringed by an elevated viewing platform, while along the perimeter of the circular space binders containing the Pages of Testimony of Holocaust victims fill rows of shelves. Unfortunately, the photos and Pages of Testimony reproduced in the heaven of the dome are too high to read, and the binders appear more a decorative device than an archival resource. Apart from this would-be tour de force, though, the collaboration and counterpoint between curatorship and architectural design remain admirably balanced and harmonious.

Exiting the viewing platform at the museum's northern end through another wide concrete aperture, the visitor enters a sunken square courtyard paved with the familiar local limestone and planted with a grid of trees, the spatial inverse of the reception pavilion. Around its perimeter are a new synagogue, a permanent museum of Holocaust art, a space for temporary exhibitions, and restaurant and washroom facilities. Unlikely as it seems that one would feel like drinking a cup of coffee after staring at photos of starving concentration camp inmates, the tranquility and everydayness of this amenable sun-washed space make it feel not blasphemous to do so. From here one ascends by stair or escalator to an upper plaza and some of Yad Vashem's preexisting buildings and grounds, which have been rewoven into the new fabric of the site by the landscape architect Shlomo Aronson. The museum may now be glimpsed again from the plateau atop it by peering through the triangular skylight, crossed at two points by a walkway and road. One wanders through Safdie's two earlier installations. The Children's Holocaust Memorial is a cave-like space filled with pinpoint lights and echoing with the sonorous intonation of the names of young victims; the Memorial to the Deportees, a railroad car

pitched precariously over the valley on severed tracks. Moving though they are, these structures cannot help but seem a little anticlimactic at this point in the circuit. Finally one arrives back at the original screen wall and hails one of the taxis hovering around. On the return to downtown Jerusalem, the conversation inevitably turns to politics. "Americans are more interested in the Holocaust," the driver accuses, "than in Israel's present-day situation." But Yad Vashem has demonstrated how inextricably one history is linked to the other.

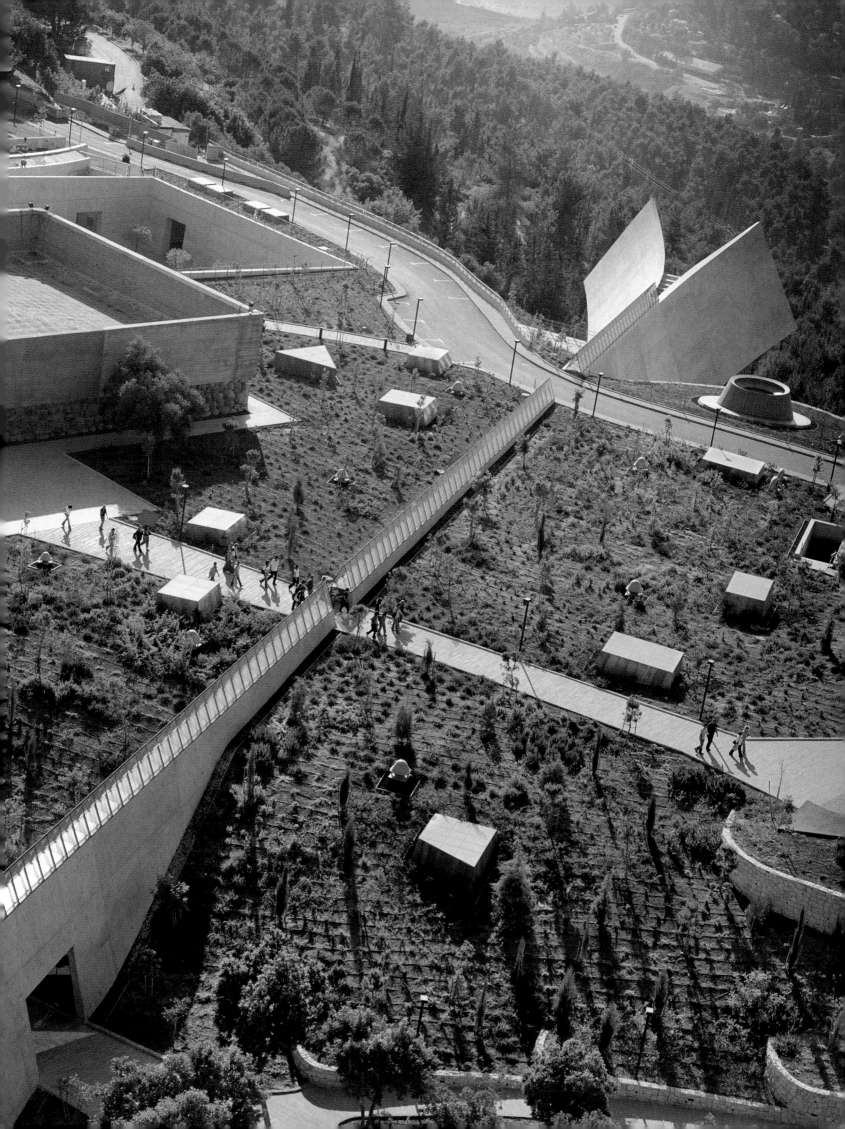

1 Gateway Wall
2 Entry Piazza (underground parking below)
3 Visitors' Center (*Mevoah*)
4 Museum Shop
5 Administration Building
6 Entrance Bridge
7 Holocaust History Museum
8 Hall of Names
9 Courtyard

10 Museum of Holocaust Art
11 Exhibitions Pavilion
12 Visual Center
13 Learning Center
14 Synagogue
15 Café
16 Warsaw Ghetto Square
17 Avenue of the Righteous Among the Nations
18 Hall of Remembrance
19 Children's Holocaust Memorial

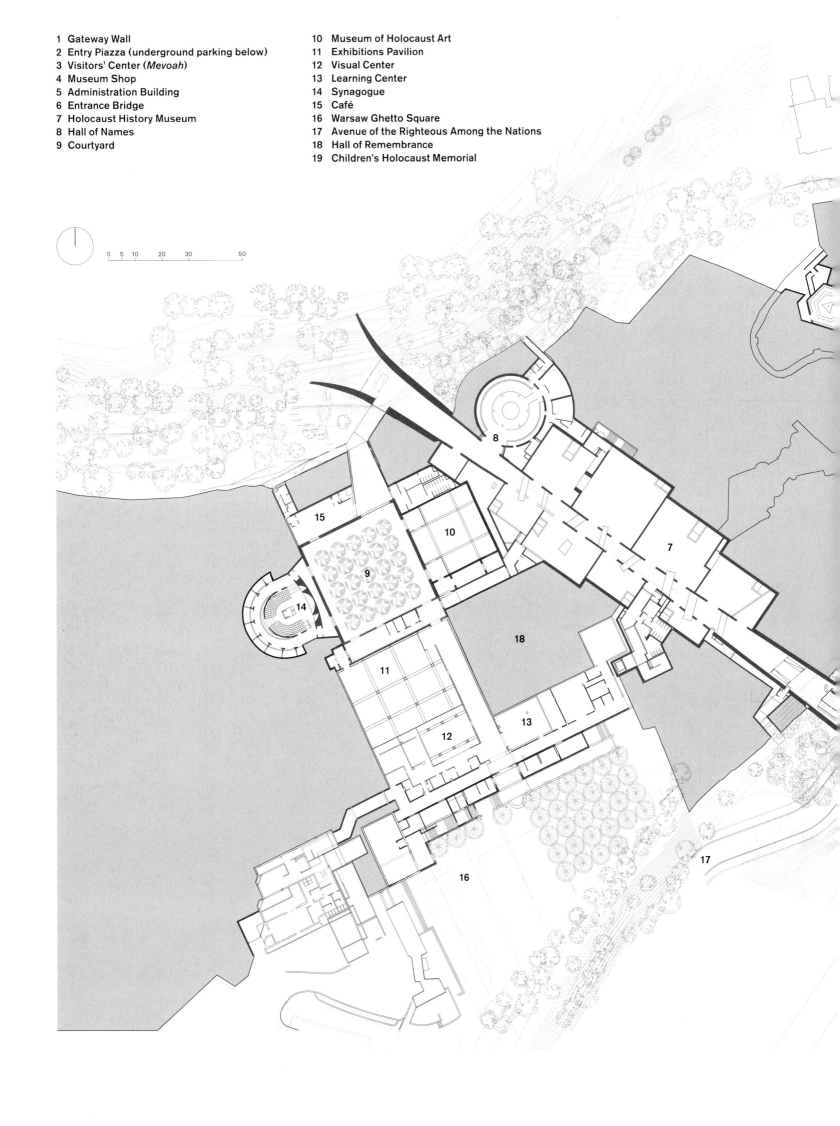

0  5  10    20    30      50

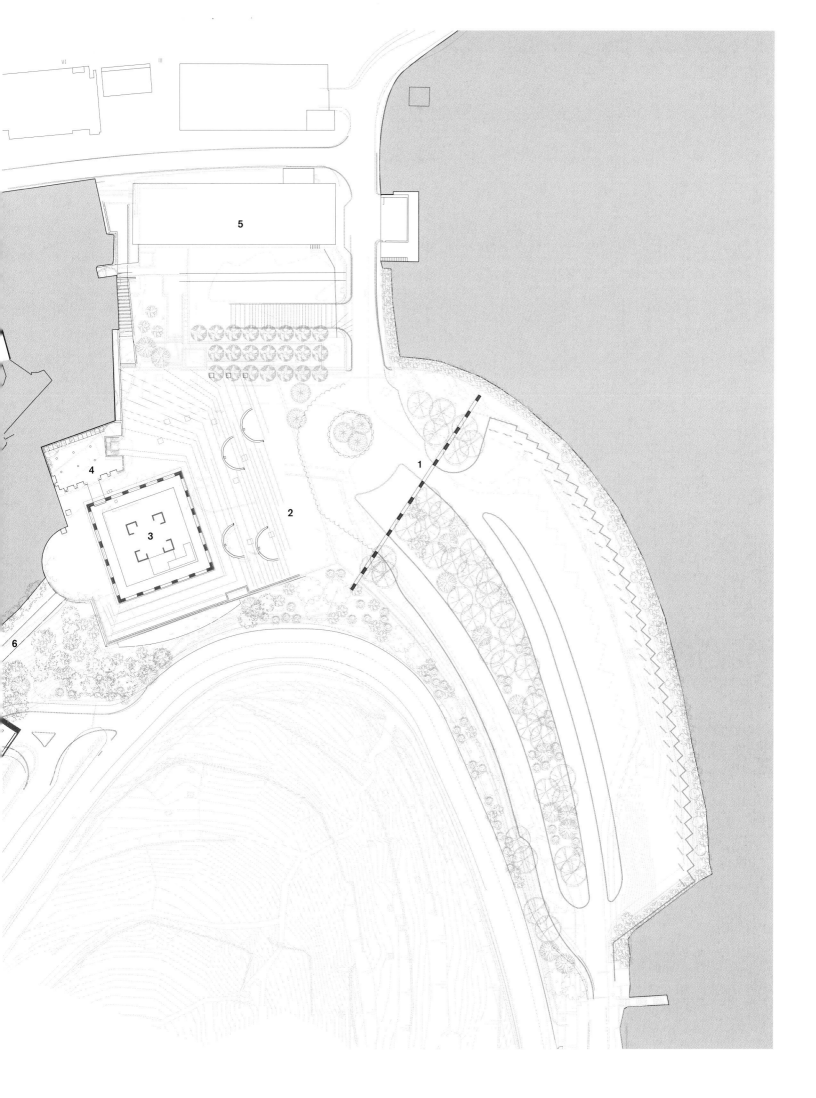

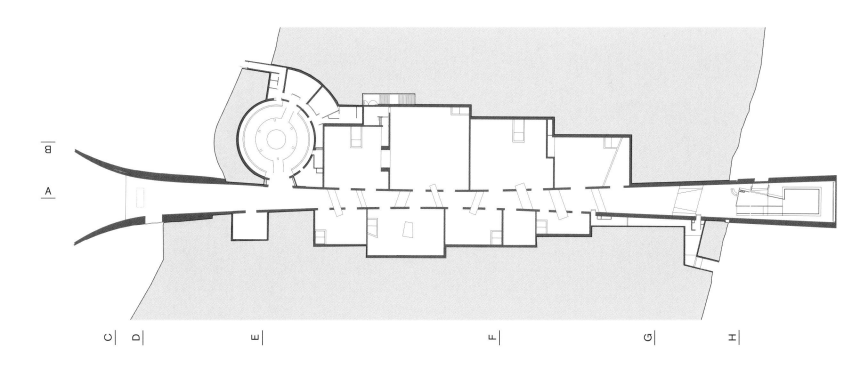

B

A

C| D| E| F| G| H|

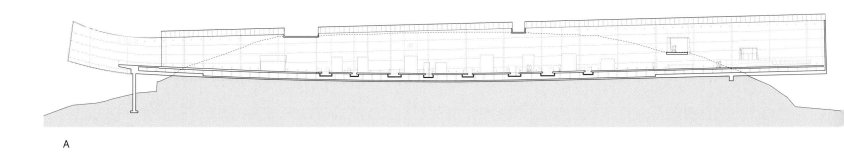

A

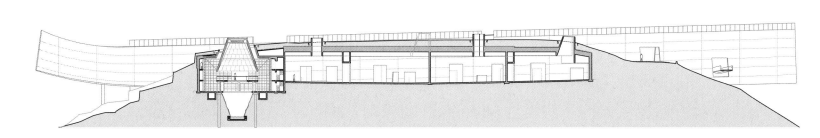

B

0 5 10   20   30      50

C

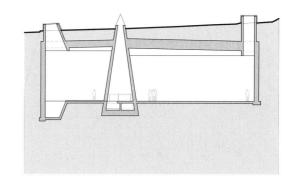

F

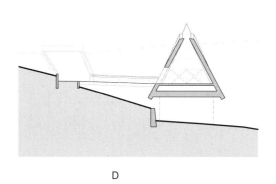

D

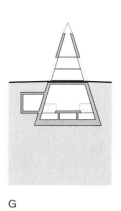

G

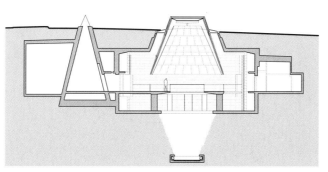

E

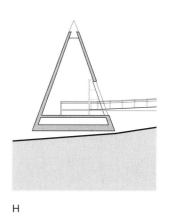

H

0    5    10        20        30                    50

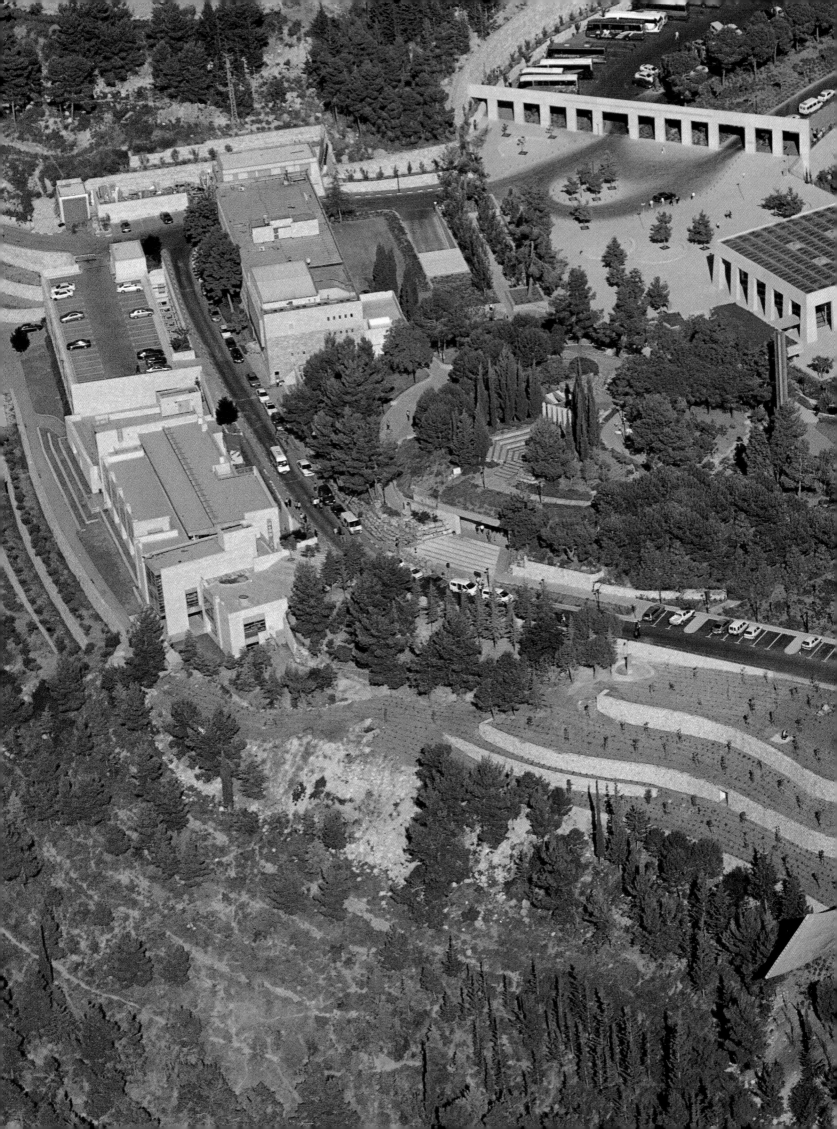

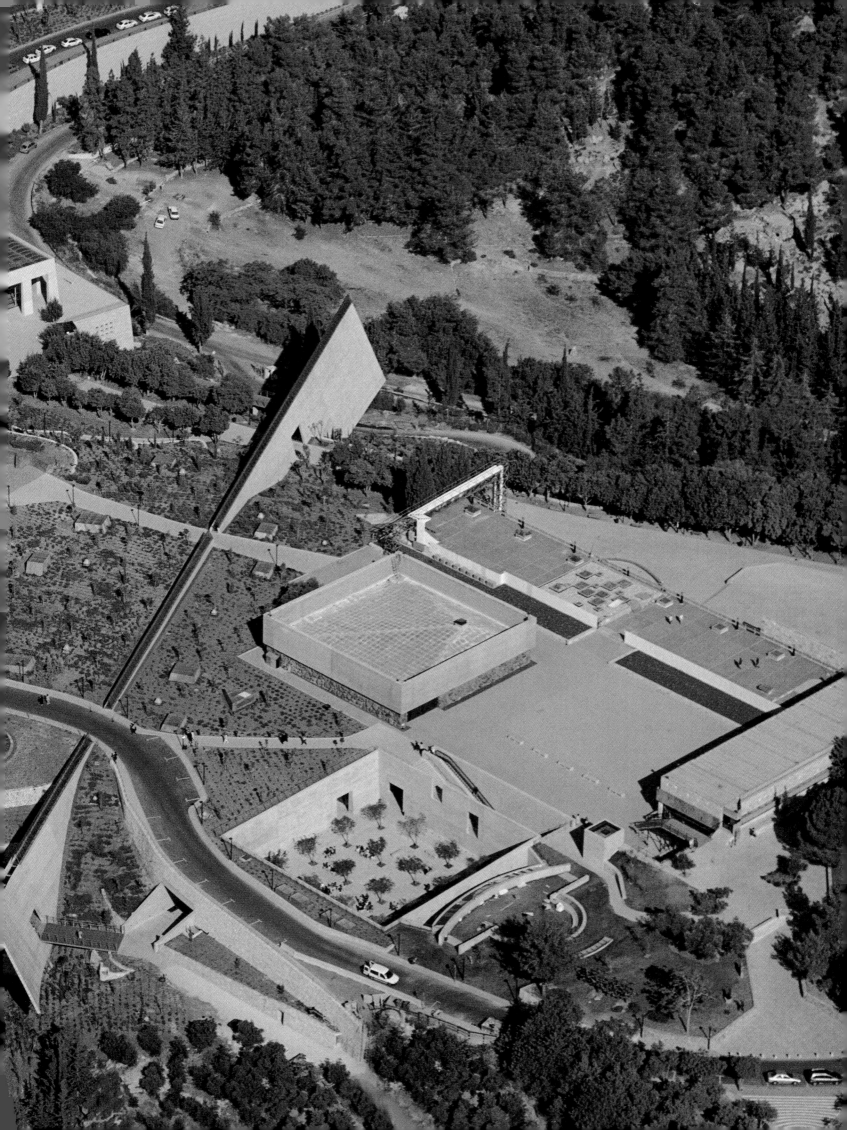

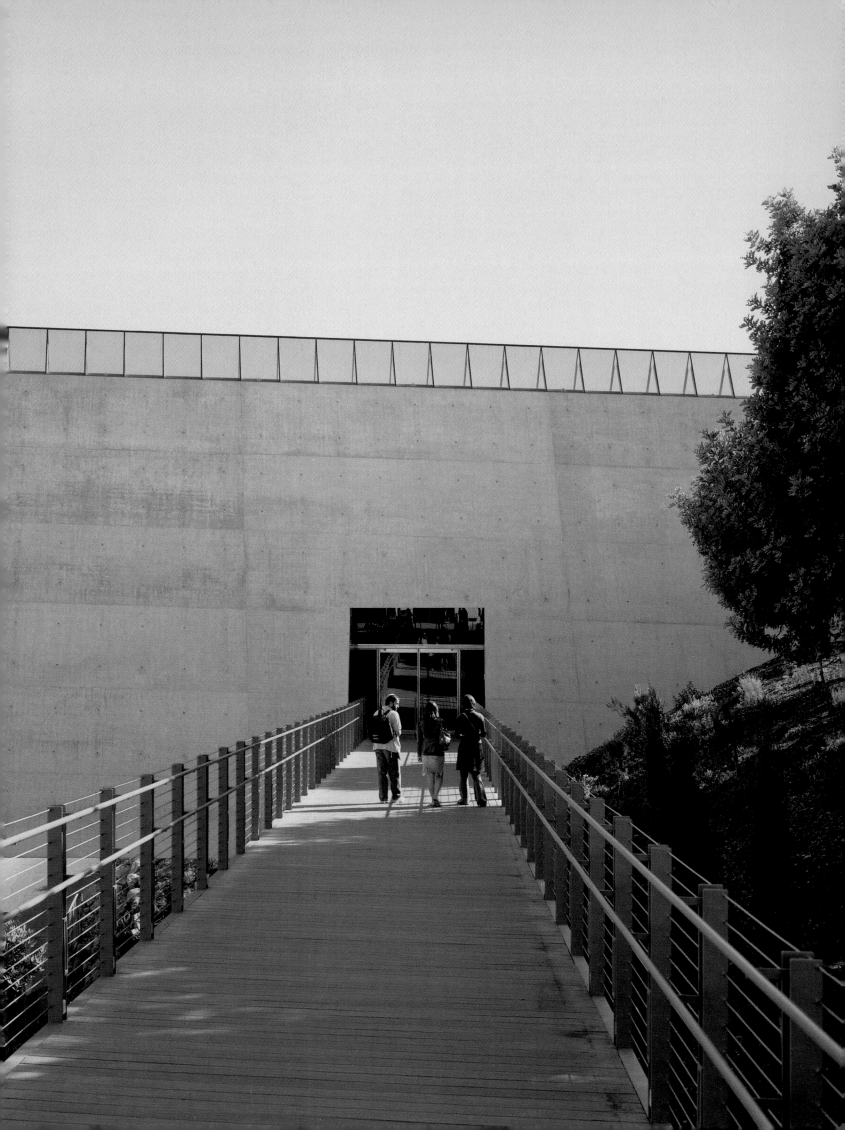

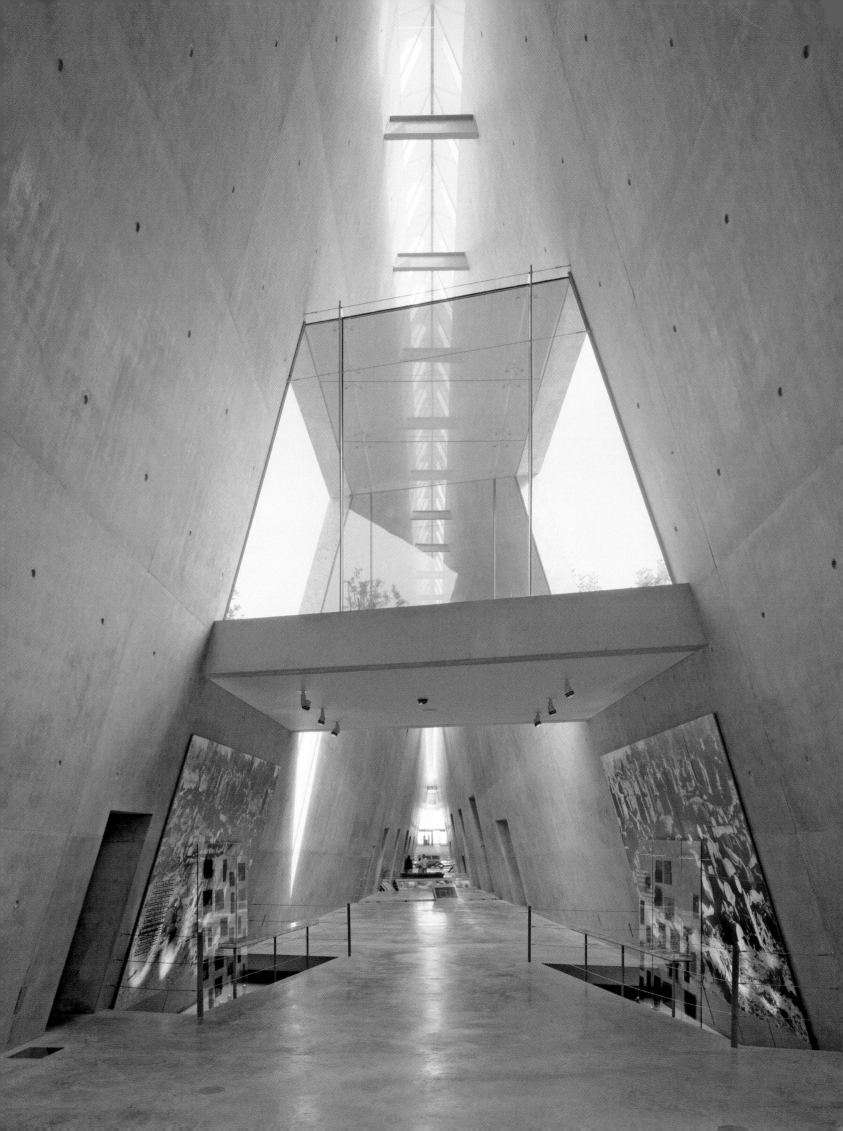

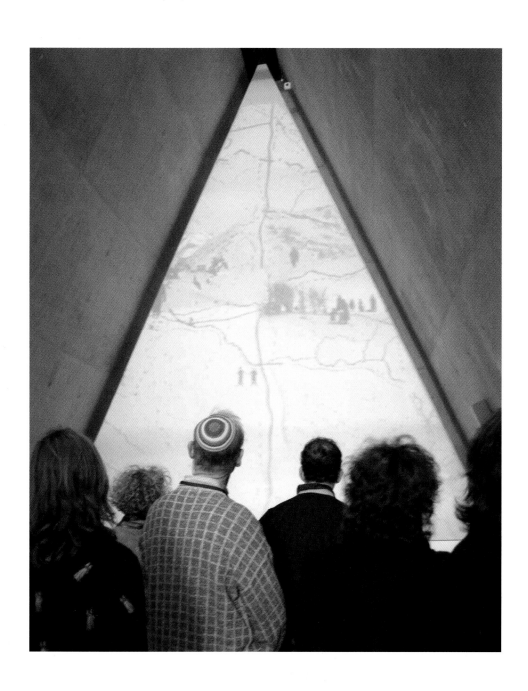

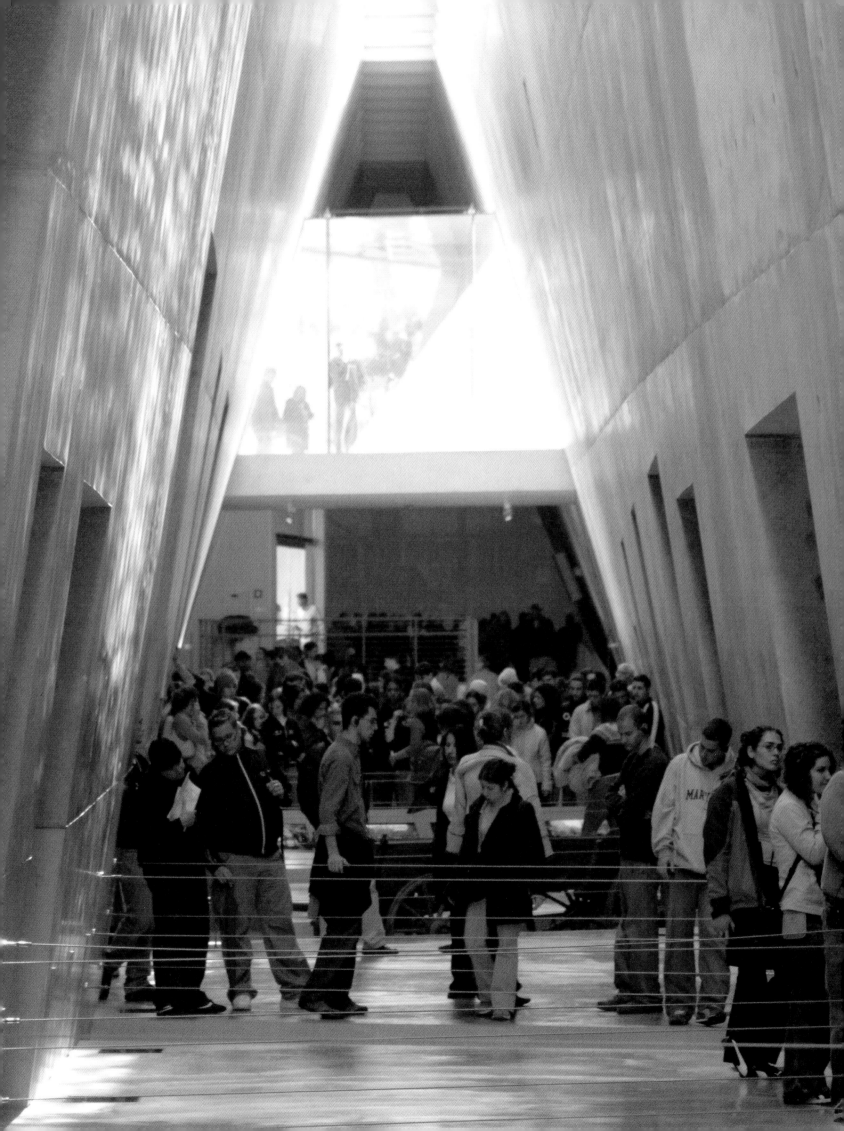

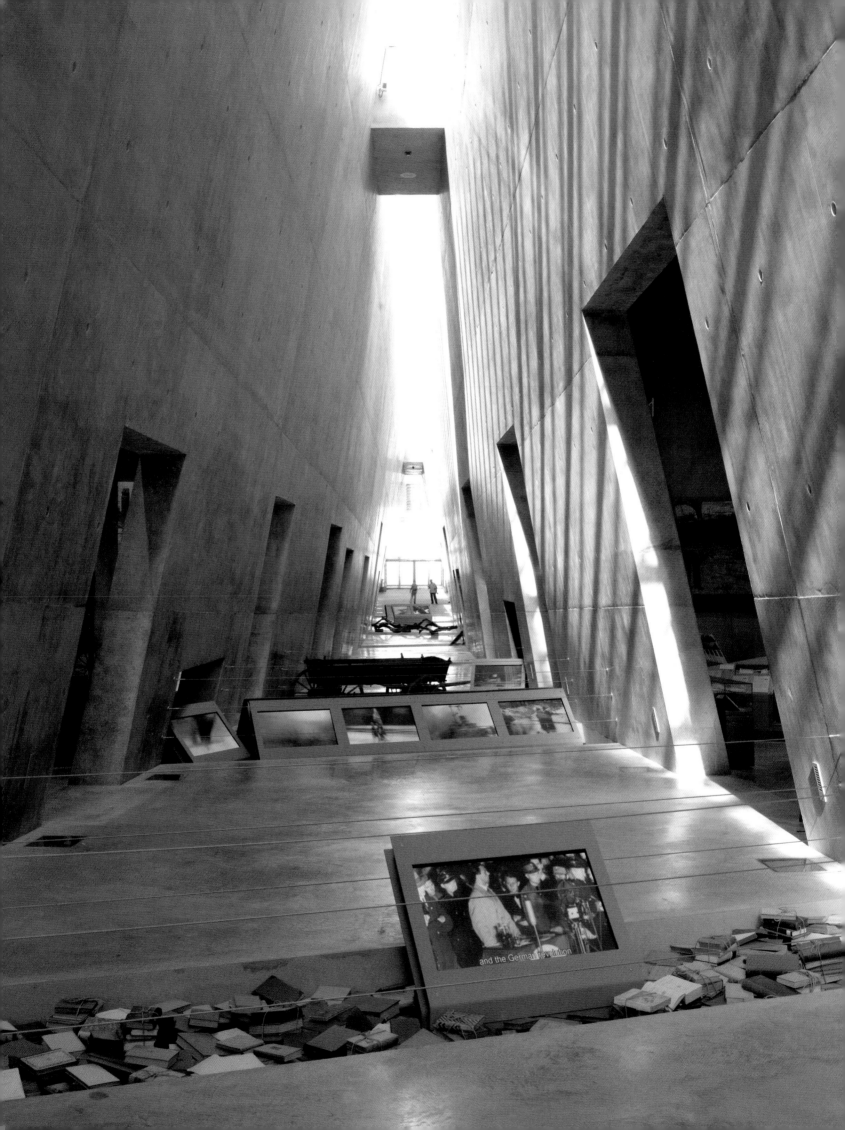

and the German revolution

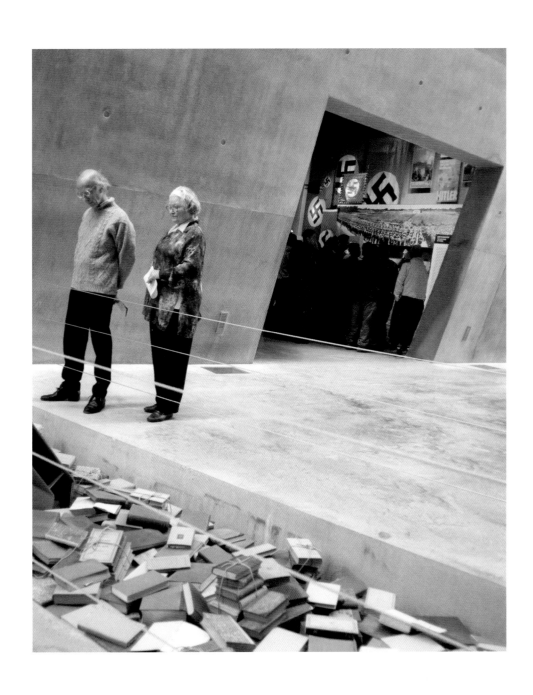

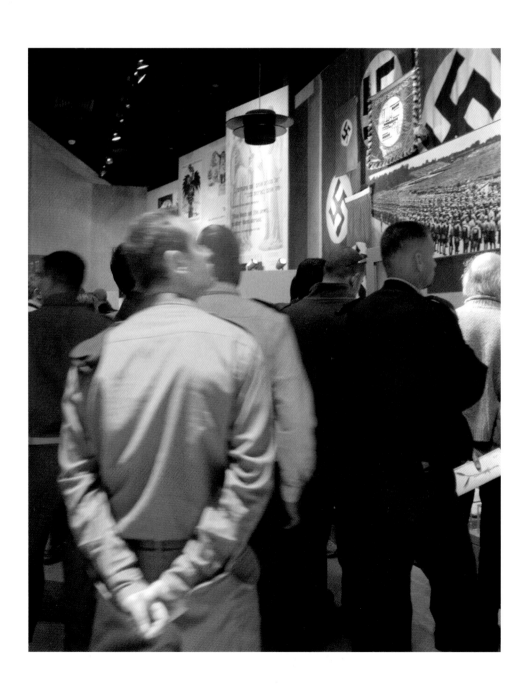

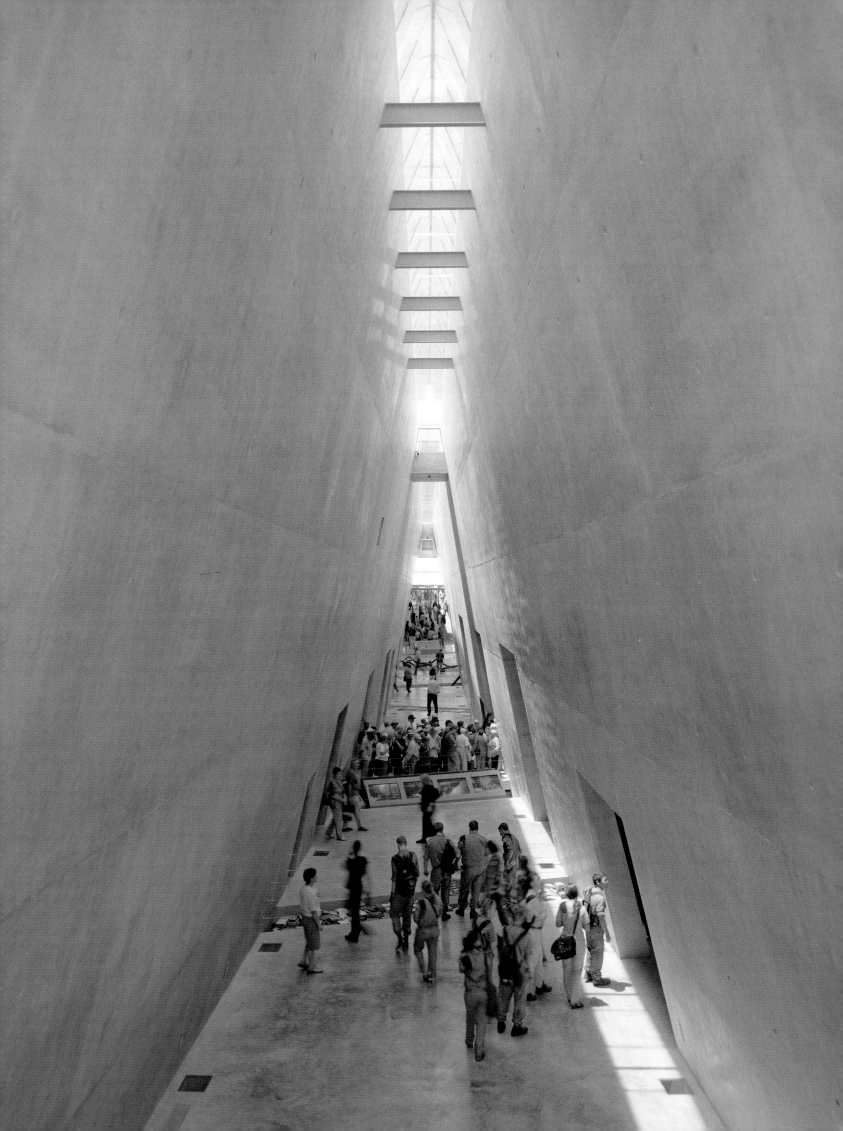

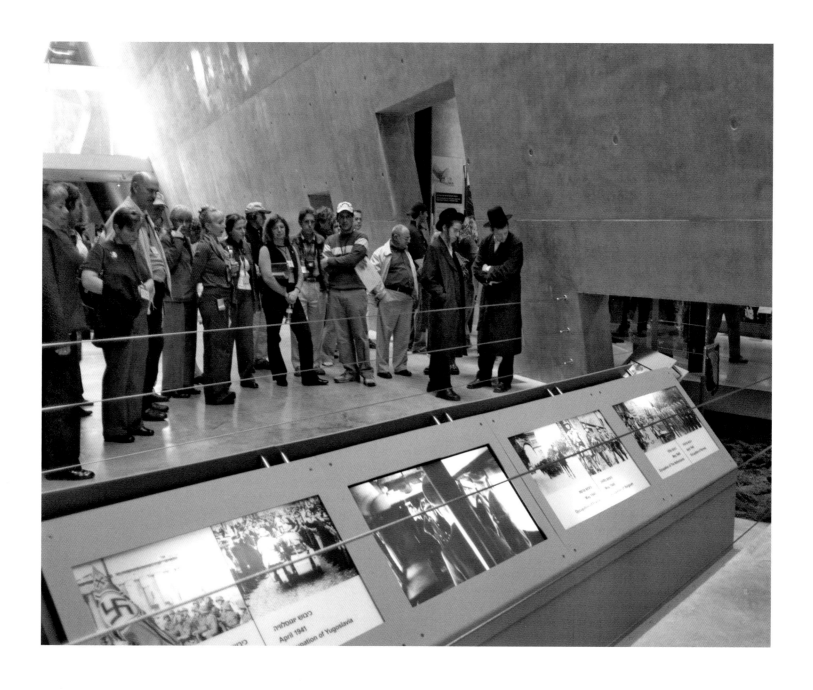

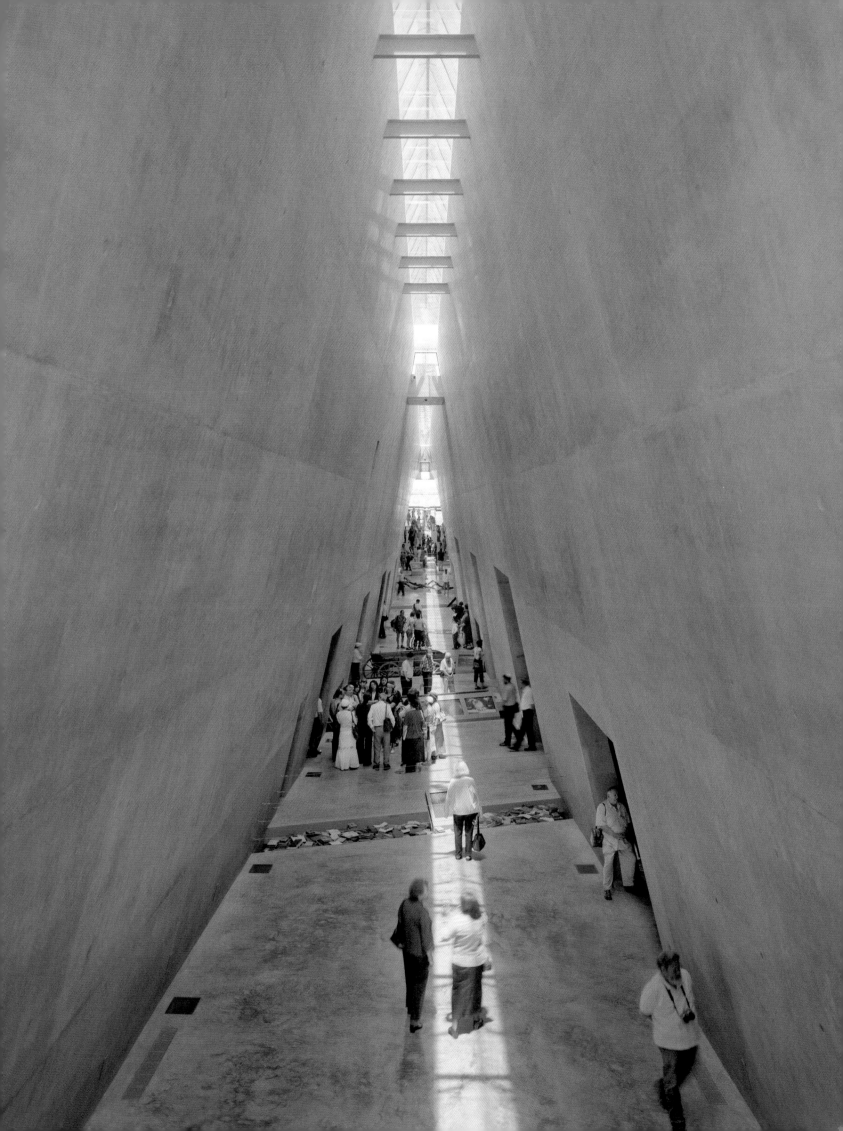

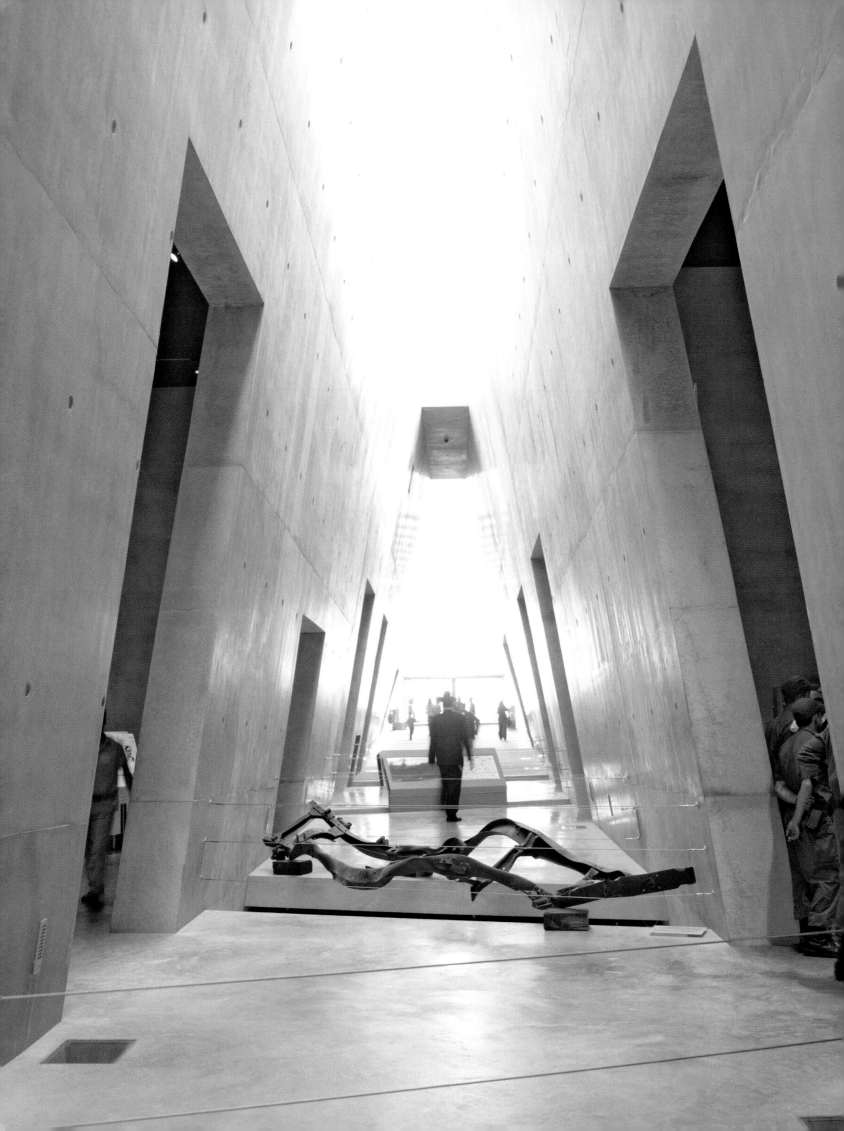

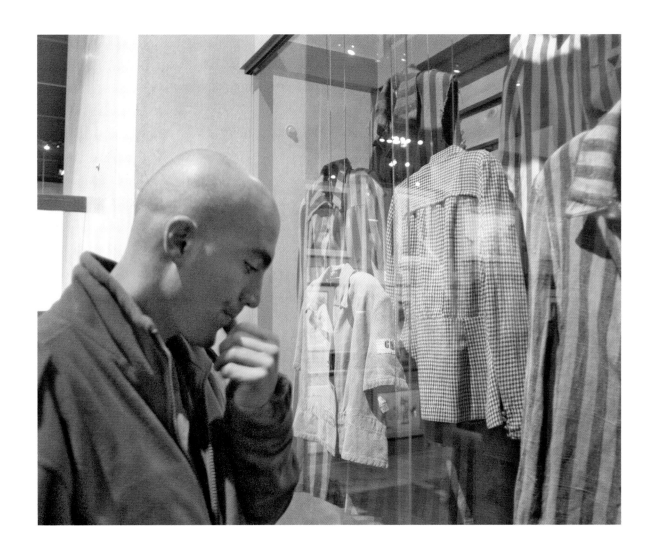

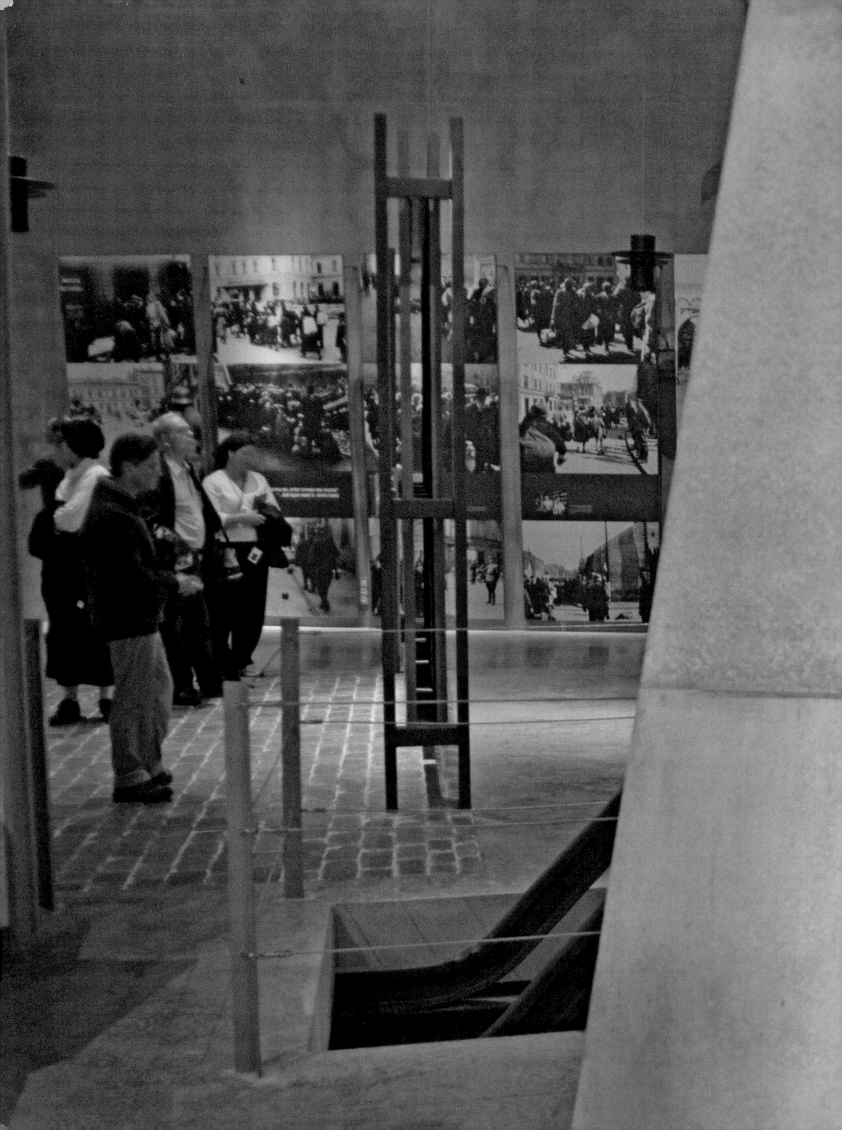

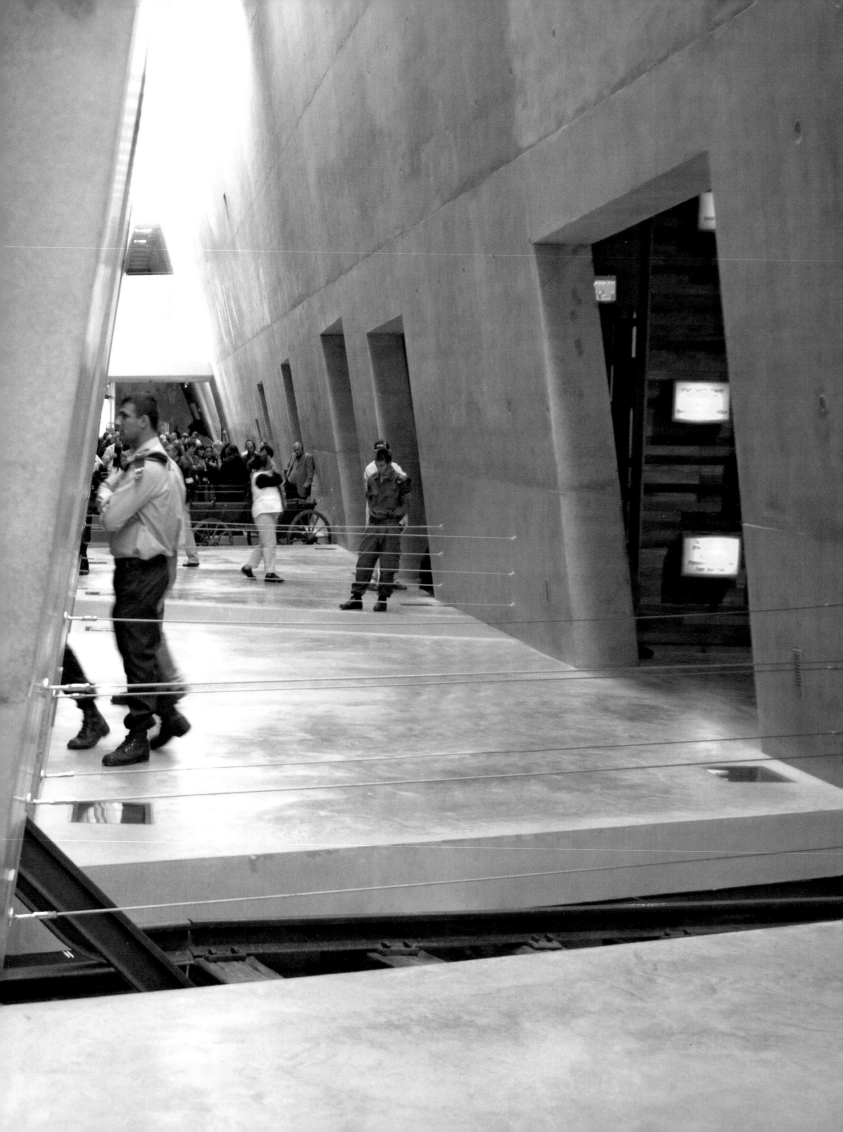

# Building a Holocaust Museum in Jerusalem

Avner Shalev

Visitors to Yad Vashem cross a narrow bridge on their way to the Holocaust History Museum. A concrete wall that pierces the mountain looms overhead. When they enter the museum, they encounter a prismlike structure that slices into the mountainside. A segment of sky is visible overhead. On the triangular wall to the left are scenes of people moving about, part of a video art presentation by Michal Rovner using authentic images from the diverse and vibrant prewar Jewish world. The images and sounds of this montage invite viewers to consider the lives that these people led—ordinary but effervescent lives that were about to come to an abrupt, catastrophic, and unforeseeable end.

At this stage visitors turn from that bygone world and begin to move through the prism, which continues to the exit, where they will be greeted by another segment of sky and the view of present-day Jerusalem.

In what context is the new museum set? Against what background did the new concept emerge and the program take shape?

When I was offered the directorship of Yad Vashem in the early 1990s, succeeding the retiring Dr. Yitzhak Arad, a Holocaust survivor and respected historian, I hesitated. But I came to realize that my generation must assume responsibility for shaping the memory of the Holocaust. I considered the challenge a privilege and tackled it in fear and trembling.

I am not the son of Holocaust survivors. I am a Jerusalem-born Sabra. Part of my family had been murdered back there, in Europe. Like many of my contemporaries, I was not privileged to know my grandparents, uncles, aunts, or cousins. I was raised on the educational principles of Israel in those days— Jewish, humanistic, and socialistic. We dreamed of building a home for the Jewish people in the Land of Israel and of raising a new Jewish generation, changing the world, and healing the fractured, shattered lives of post-Holocaust Jews.

Yad Vashem, the State of Israel's remembrance authority established on behalf of the Jewish people long ago, formed and consolidated a "place" for sharing and perpetuating memory—Har Hazikaron, the Mount of Remembrance. By the early 1990s Yad Vashem—an institution of documentation, research, education, and commemoration—had become synonymous with Holocaust remembrance among Jews and non-Jews around the globe.

We were on the verge of a new century. Examining the shaping of identity pointed to young people's growing interest in the Holocaust. The young whom we were addressing were the leaders of the future. They had learned about the high hopes and optimism for progress that had introduced the twentieth century. Instead, they found the most murderous and brutal century in history—one that witnessed world wars and the Holocaust, the murder of the Jewish people, an act unprecedented in the annals of humankind. What is more, people's behavior during the Holocaust raised fundamental questions regarding humanity.

For Jews, the Holocaust is an experience that has been seared into our identity and forces us to ask difficult historical, creedal, moral, and educational questions. Foremost among them are why and how an ideology of total

The ghettos of Kovno, Lodz, Terezin, and Warsaw
The perpetrators

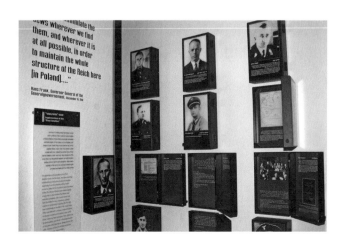

murder took form, how the murder of a people and the destruction of Jewish existence in Europe, amid the indifference of the Jews' neighbors and the world's silence, became possible. The ongoing discourse will determine whether the Holocaust becomes just another event to be studied in history books, or whether its examination and memorialization lead to a heightened consciousness of the event's significance that can shape the face of civilization. Will humankind develop a broad commitment to creedal, religious, and human values that bind the individual human being, created in God's image, who lives by the commandment "Do not murder" and is devoted to the preservation of human freedom, dignity, and rights?

With these thoughts in mind, we embarked on the redevelopment of Yad Vashem. We elaborated a comprehensive master plan that included the establishment of the Yad Vashem International School for Holocaust Studies; the online digitization of the information and knowledge that Yad Vashem had amassed in order to make it easily accessible around the world in an era that has seen a communications revolution; the construction of a new building for the archives and library; the expansion of our research and publication divisions; and the building of a new museum complex. This would transform the focus of Har Hazikaron from mainly a commemorative site into a campus that engages dynamically in education and the dissemination of knowledge in Israel and abroad, including laying the groundwork for molding a type of remembrance that would be meaningful and relevant in a rapidly changing world.

With architects David Reznick and Dan Tzur we sketched out three areas on the Yad Vashem campus. On the northeast side of the hill the documentation center, the school, the research facilities, the computer systems, and the administration would be concentrated in three buildings. The center of the campus would be reserved for the commemorative sites and the museums, with the Hall of Remembrance looming over all the other structures. The third

area, on the western side of the hill, would include the Valley of the Communities, the Garden of the Righteous Among the Nations, the Memorial to the Deportees, and the Memorial to the Jewish Soldiers and Partisans. The overall scenic nature of the hill would be preserved—a wooded place where the various sites would be integrated into their surroundings. It became clear that we should begin with the school and archives and end with the museum complex, composed of a Holocaust history museum, an art museum, an exhibitions pavilion, a visual center, a learning center, and a synagogue.

When we began to plan the Holocaust History Museum, we put together a task force to develop the museum program. The team included Prof. Israel Gutman, a survivor and one of the most important Holocaust historians; Yehudit Inbar, who as director of the Yad Vashem Museums Division brought her professional expertise in museum curatorship and developed the museum's collections, and who served as curator in charge, leading the large team of curators and researchers; the historians Dr. David Silberklang, Dr. Avraham Milgram, and Naama Galil; the pedagogue Shulamit Imber; and myself as chief curator. After the principles were worked out, designer Dorit Harel joined the team and contributed greatly to the creative process.

The deportations
Treblinka

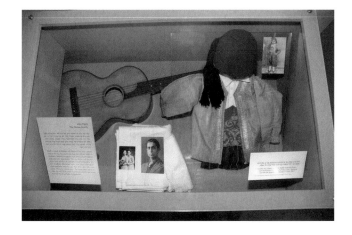
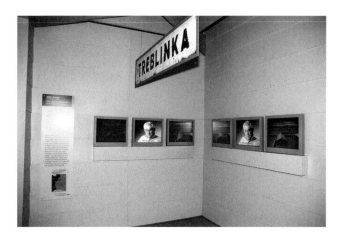

Early in the planning phase we made two definitive decisions. First, the museum would take a Jewish perspective, presenting the story as much as possible from the point of view of the individual Jew and how he or she coped with the Holocaust. Second, the museum would tell a historical narrative with a beginning, middle, and end—laid out along a path that visitors would follow. As they progressed along this route, visitors should be able to connect and empathize with the victims as those unforeseeable and inconceivable events unfolded. We did not wish to dictate lessons or messages, overt or covert. At the end of their journey, visitors should emerge with unanswered questions, want to make their experience meaningful, and, perhaps, ask themselves where their commitment and responsibility lie. Certainly, they should ask questions about human evil and the duty to defend the values of human society. For Jewish visitors, we had an additional aim: they should reflect on the continued survival of the Jewish people and its Jewish and human values.

We decided to develop the narrative by means of individualization and creating an eye-level encounter between the narrator or witness and the viewers. This led us to a two-tiered exhibit structure: the context—describing the historical processes—and the text—telling the story at the personal level. We wanted the public to move from overview to specifics, back to overview, and back to specifics again, entering into a dialogue with the individual victim coping with events.

As visitors leave behind the flickering images of the world that has vanished, they come to a point of crisis. They are confronted by large photographs on both sides of the prism. Each one shows a heap of logs, on top of which are the corpses of Jewish prisoners who were killed in the camp in Klooga, Estonia, in September 1944 as the Red Army advanced. In the foreground are charred photographs that were found in the victims' pockets and reflect the story of their lives. These photos seem to have been pulled from the opening

montage and placed here, where the mass murder is recounted. We chose to present the story of the murders at Klooga at the opening not because it was an exceptional event in Holocaust history, but rather as an introduction to the layered structure of the exhibit and to the narrative related in the museum.

These principles—the narrative of the museum and the basics of the museum language—constituted the programming challenge that we posed to the architects. In terms of physical structure, we wanted neither a black box nor a building that would stand by itself as a memorial. Moshe Safdie's proposal was selected because it allowed the development of a dialogue between the prism, piercing the innards of the mountain without losing contact with the outside world, and the galleries, which branch off of both sides of the prism in a zigzag pattern that leads to the unexpected contents on display. In this manner, the museum building would establish a supportive and complementary relationship between the architectural dimension and the exhibition design. Safdie's solution fused simplicity, expressed in an almost ascetic use of materials, with a sense of power that would reach its pinnacle at the exit.

Auschwitz-Birkenau
Artwork made by former camp inmates

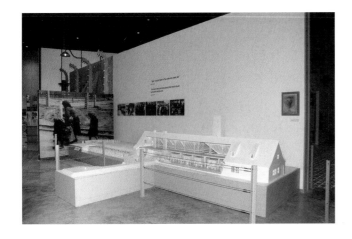

During the planning phase, we asked ourselves how the prism and the galleries would interrelate and how to incorporate the prism itself into the exhibit. We decided to invite viewers to follow the narrative and to prevent them from moving only along the prism. Harel and Safdie's suggestion was to open ruptures in the prism floor at the gallery entrances, maintaining the sightline along the entire spine. This concept became part of the architecture and of the structure-exhibit dialogue. We decided that these ruptures in the floor and their exhibits would represent turning points in the narrative, and that there would be no other exhibits in the prism. In the first trench, for example, we placed a book-burning exhibit, symbolizing Hitler's accession to power and the intensity of the Nazi revolution, with its destruction of the foundations of Western civilization epitomized by the annihilation of the Jewish people.

Here visitors enter the gallery that presents the first six years of Nazi rule. The complexity of the events necessitates a chronological and thematic approach. This allows us to address collateral phenomena that occurred in different ways, in different geographic locations, and at different times. For example, the Germans ultimately interned Jews in more than one thousand

The Righteous Among the Nations: the non-Jews who defied the indifference and hostility toward Jews

The death marches

ghettos. The museum illustrates this in the fourth gallery by telling the stories of four ghettos, irrespective of chronology.

The contents of the galleries reflect both the well-known themes of the Holocaust era and the latest research on the subject. It was on this basis that we reexamined the relations among the themes in each gallery and among the galleries. For instance, the research shows that the ghetto uprisings can be understood only within the context of the extermination process to which they reacted. Therefore, we included the uprisings in our account of how knowledge and awareness of the totality of the Final Solution developed. We sought ways to represent the diverse geographic areas and the numerous communities affected by the Holocaust without interfering with the continuity of the narrative. We wished to call visitors' attention to the fact that the Holocaust spanned the entire European continent, that the process was set in motion in northern Africa, and that it threatened to reach the Middle East. Wherever the Germans came, the Jews faced the same process: displacement, concentration, deportation, and extermination. This approach also led us to address daily life in the camps after the section dealing with the extermination; it sharpens the visitors' understanding of the plight of the Jews. The gallery

Artifacts from daily life in the camps

Liberation

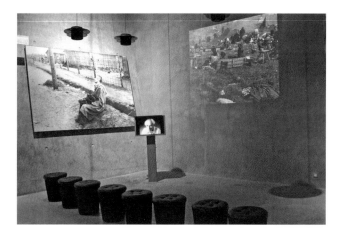

that deals with the extermination offers an unobstructed view from the section on the Birkenau camp into the area devoted to daily life in the camps, where the few survivors of the "selection" were imprisoned.

The last gallery recounts how the displaced survivors reestablished their lives. After realizing that their homes and families in Europe had been destroyed, the survivors did not wallow in despair and lust for revenge. Instead, they placed their anguish, agony, and grieving "on hold," while rapidly moving to rebuild their lives and set up new homes, whether as participants in establishing the State of Israel or elsewhere. We see here two axes in their postwar lives: channeling their pain and loss into keeping the memory alive, and displaying almost superhuman energy in rebuilding their Jewish lives.

The exhibit's museological language was a fundamental issue. We decided that a virtual exhibit employing cutting-edge technology was inappropriate. Rather, authenticity would be our calling card—a rich, three-dimensional authenticity, anchored in artifacts and bracketed by photographs, documents, texts, and contemporaneous artwork. The medium was to be an integral part of telling the story; the artifact was to be a means of personification. Looking at the crumbling eyeglasses that Tula Meltzer's mother handed her as they stood in the "selection" at Birkenau, while listening to Tula's testimony, visitors gain insight into the intensity of family relations.

We interweave contemporaneous artwork into the exhibit as an expression of the creative endeavor of people struggling to survive both physically and spiritually. The paintings of the young and talented Charlotte Solomon poignantly express the demise of her family and of German Jewry. Yehuda Bacon conveys the terror of the crematorium in Birkenau, where his father was murdered and where he himself survived. Portraits of the Jews in Terezin, struggling to maintain their humanity while wasting away from starvation,

amplify the horror. We identify with the sense of loss communicated by the understated painting *Mother Is No More*, made by the boy who would eventually become the artist Shmuel Bak.

Film is integral to our presentation of the Holocaust, and we consulted cinema experts to help us find the most appropriate way to integrate this medium into the exhibit. We did not want separate movie spaces, but rather to integrate survivors' testimonies with artifacts and photographs. It is the witnesses who sit down and look visitors in the eye, preparing to retell their stories despite the psychological hardship it will cause them. The result is direct contact, devoid of acting and pretense.

The tour of the museum concludes with the proclamation of the establishment of the State of Israel—a sovereign Jewish state that went on to receive the survivors who were released from the DP camps. The circle closes with the singing of "Hatikva," which subsequently became Israel's national anthem, by a children's choir from Mukacevo, Czechoslovakia, recorded in the 1930s —the same choir that sings at the entrance to the museum in Rovner's film montage. Most of the children in the choir were murdered at Auschwitz.

The DP camps

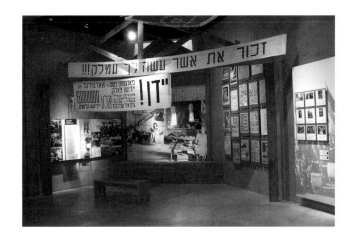

At the end of the last segment of the historical exhibit, visitors return to the prism and enter the Hall of Names. Every person is a world unto himself or herself. With the murder of each individual, his or her specific contribution to sustaining the world of the living was lost forever. Here, near the edge of the prism, we wanted to install an active archive that would present the names of Holocaust victims culled from the Pages of Testimony—forms containing biographical information about the lives and deaths of the three million known Holocaust victims. We also wanted a monument to rise from the area of the archive. Safdie's impressive architectural expression took the form of two cones—one towering skyward and the other sunk into the bedrock of the Jerusalem hills. Visitors enter the hall and are surrounded by the circular repository housing the pages. Above, they see photographs of hundreds of the victims against the background of the Pages of Testimony. With this installation, Harel and the Hall of Names staff created a cross-section of the Jewish people as it had existed before the Holocaust. Visitors faced with this salvaged information are also confronted with the idea of how many names are still missing. The victims peer at us as if seeking a response...and perhaps inspiring us, the visitors, to reflect about personal responsibility.

Before leaving the building visitors pass through a room for contemplation that features a video art installation created by Uri Tzaig. In one corner they see the image of a book, whose continually turning pages show changing calligraphies. In another corner floating letters projected against the walls occasionally combine to form words from the diaries, letters, and missives written, most during the Holocaust, by victims as they coped with the imperative to live.

Returning to the prism visitors are lured by the segment of sky to the terrace. Behind them the images of the past continue to flicker across the triangular wall. Ahead of them unfolds the magnificent landscape of the Jerusalem hills.

*The Mount of Remembrance*

*Situated on Jerusalem's Mount of Remembrance, Yad Vashem's forty-five-acre campus comprises world-class research and education centers and museums, as well as a range of monuments, memorials, gardens, and sculptures— all the necessary components for a meaningful and dynamic commemoration of the Holocaust and its victims. These all blend into the rich Jerusalem forest that surrounds the site, allowing visitors to experience its multifaceted elements in a tranquil atmosphere.*

*Established by the Knesset in 1953, Yad Vashem has become a focal point of identification for every Israeli, Jew, and person of conscience. Although more than sixty years have passed since the end of World War II, interest in the Holocaust has never been greater, and close to two million visitors continue to stream through its gates annually, eager to learn more about the most cataclysmic event in modern history and the people who lived—and died—at that time.*

*Building on half a century of collection and investigation, Yad Vashem now contains some 68 million pages of documentation, 112,000 titles in more than 50 languages, and more than 24,000 artifacts and 10,500 works of art, laying the foundation for its ongoing research and education efforts, as well as the wide range of exhibits in its museums. The state-of-the-art Archives and Library Building and International Institute for Holocaust Research make the Jerusalem campus a magnet for historians, researchers, and anyone else interested in exploring the Holocaust.*

*Through the International School for Holocaust Studies, hundreds of thousands of students and thousands of educators from Israel and around the world grapple with the history and significance of the Holocaust and its universal*

*meaning today. Using literature, art, music, drama, survivor testimonies, texts, and discussion groups, the school provides tailor-made programs and seminars offered in many languages and in some twenty countries worldwide, as well as national and international conferences on Holocaust education.*

*The primary site for commemoration on the Yad Vashem campus is the Hall of Remembrance, a solemn, tentlike structure in which heads of state, honored guests, and visitors from near and far pay their respects to the memories of the martyred dead. On the floor are the names of some of the notorious death sites, and in front of the memorial flame lies a crypt containing ashes of victims.*

*As we remember the events of the Holocaust and the lives, communities, and culture destroyed by the Nazis and their collaborators, we also recall the human spirit that, although beaten, refused to die. Ordained by the Yad Vashem Law to recognize their heroic acts, Yad Vashem has so far remembered and honored in the Avenue and Garden of the Righteous Among the Nations more than 21,000 non-Jews who risked their own lives to save Jews during the Holocaust. The Jewish partisans, resistance fighters, and soldiers who fought the Germans against all odds, and the 1.5 million children whose lives were cut short by the Nazis and their collaborators, are also memorialized in the many monuments located across the site. The Valley of the Communities, a massive, 2.5-acre monument dug out of the mountain's natural bedrock, memorializes the thousands of Jewish communities destroyed and ruined during the Holocaust.*

*Yad Vashem's new museum complex features the new Holocaust History Museum and within it the Hall of Names. The Museum of Holocaust Art houses the world's largest collection of art created under the direst of circumstances, and the Exhibitions Pavilion displays a wide variety of temporary historical,*

*thematic, and art exhibits. The complex also includes a new Synagogue for private prayer and memorial services; a Learning Center, which allows visitors to explore the moral dilemmas and other issues related to the Holocaust; and a Visual Center, where visitors may access the largest collection in the world of Holocaust-related films and video testimonies.*

*From the Mount of Remembrance in Jerusalem, Yad Vashem thus continues to strive to imbue the memory of the Holocaust with depth and meaning, and to ensure that the memory of the victims and the voices of the survivors will resonate for all generations. From here, the significance of the Holocaust is disseminated to the world—both in its meaning for Jewish continuity and in its universal significance.*

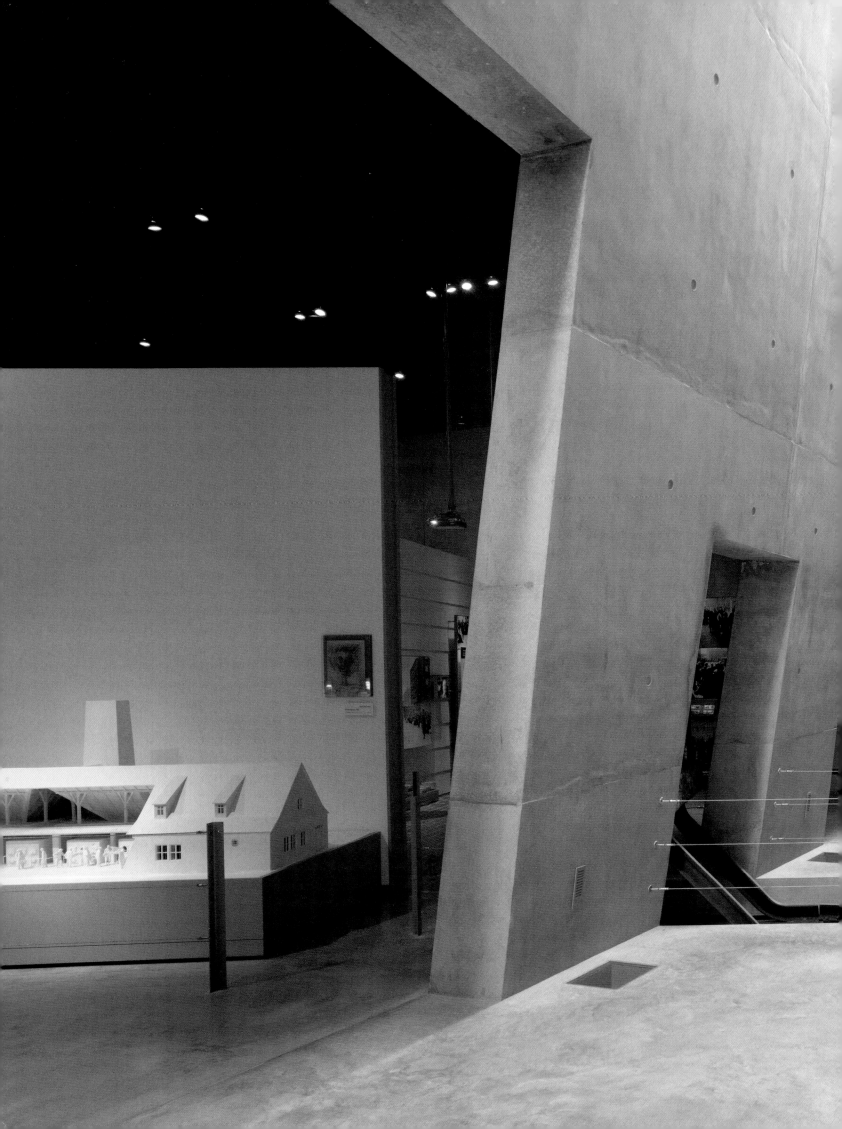

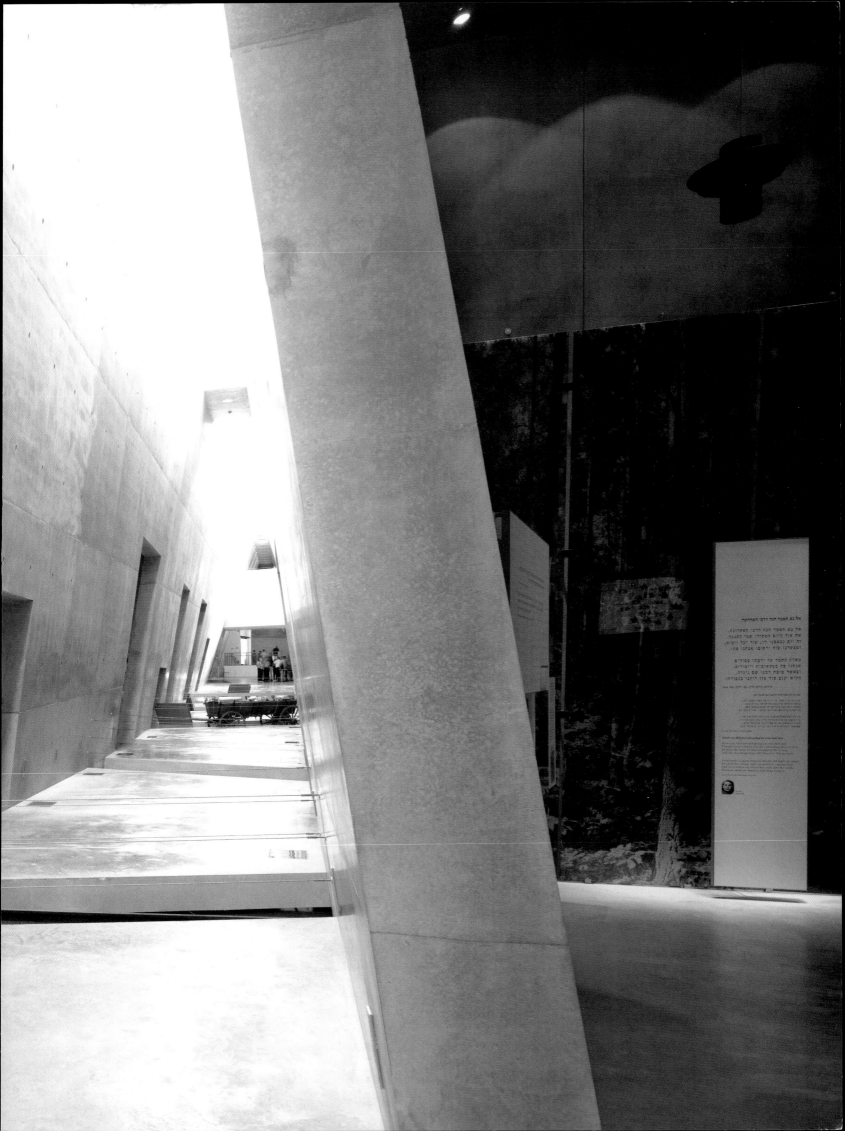

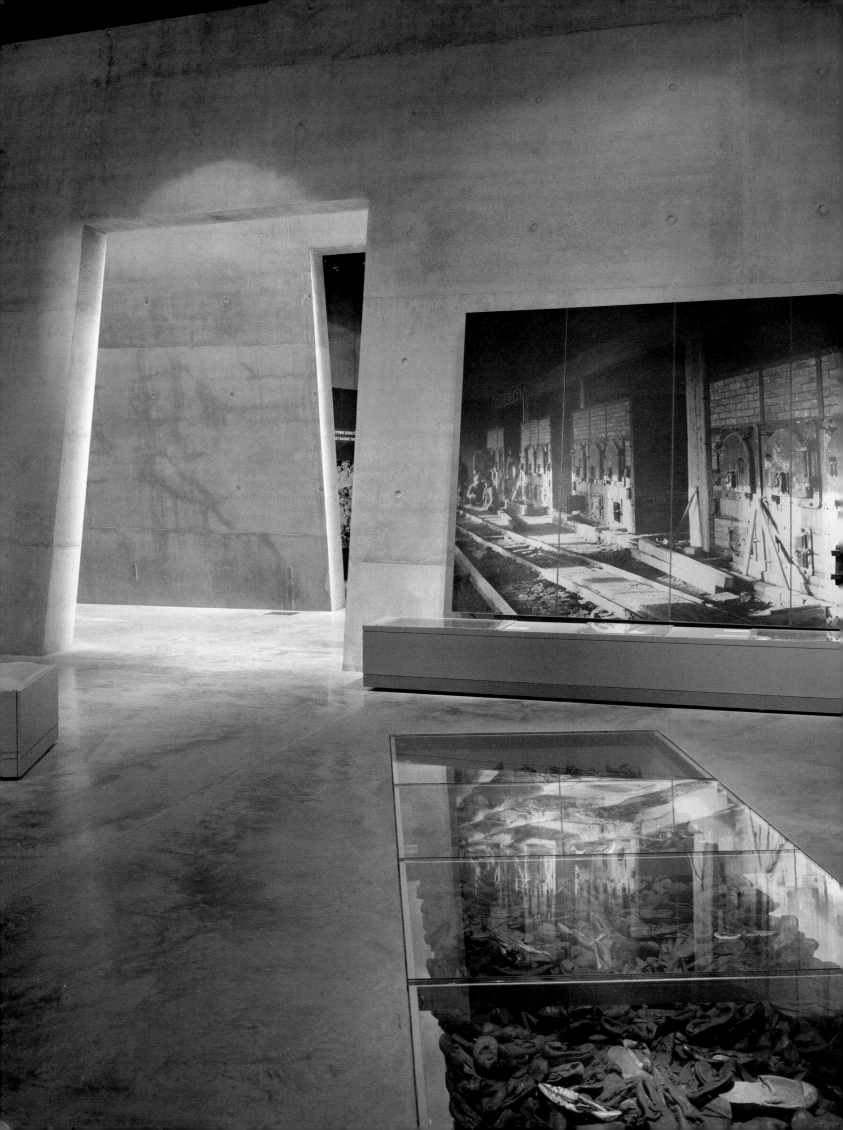

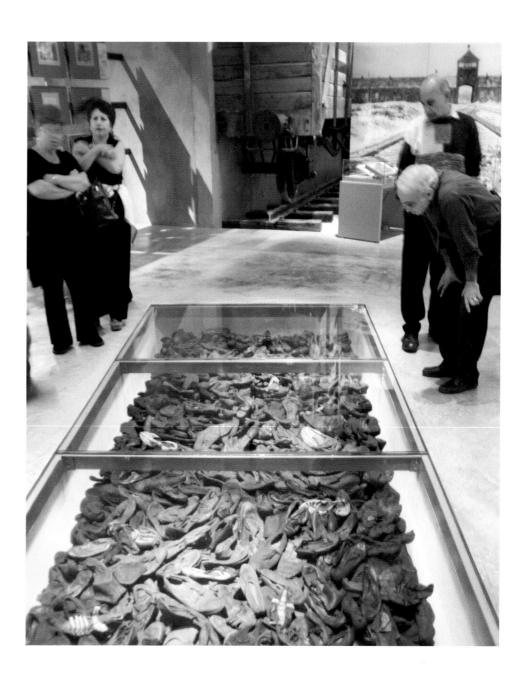

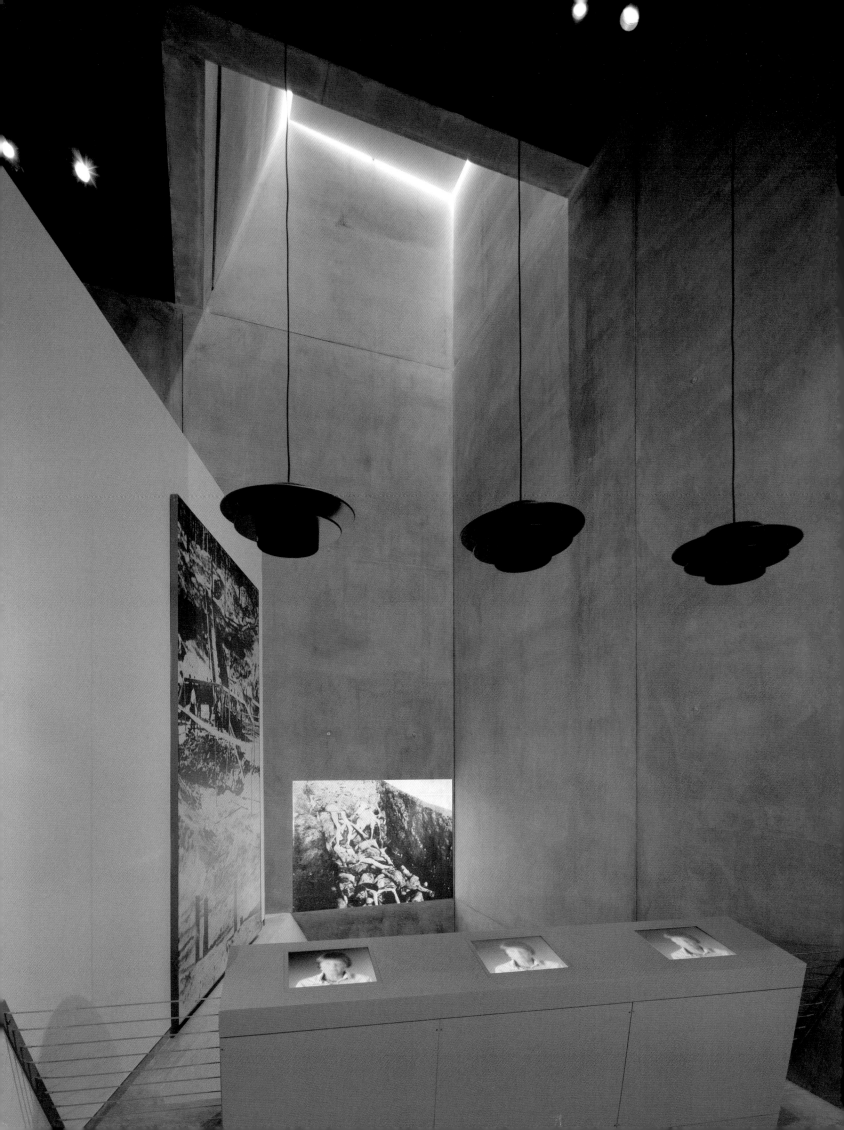

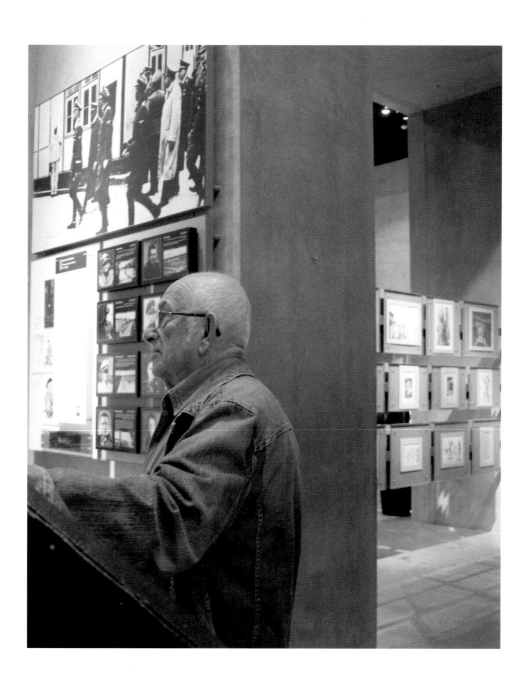

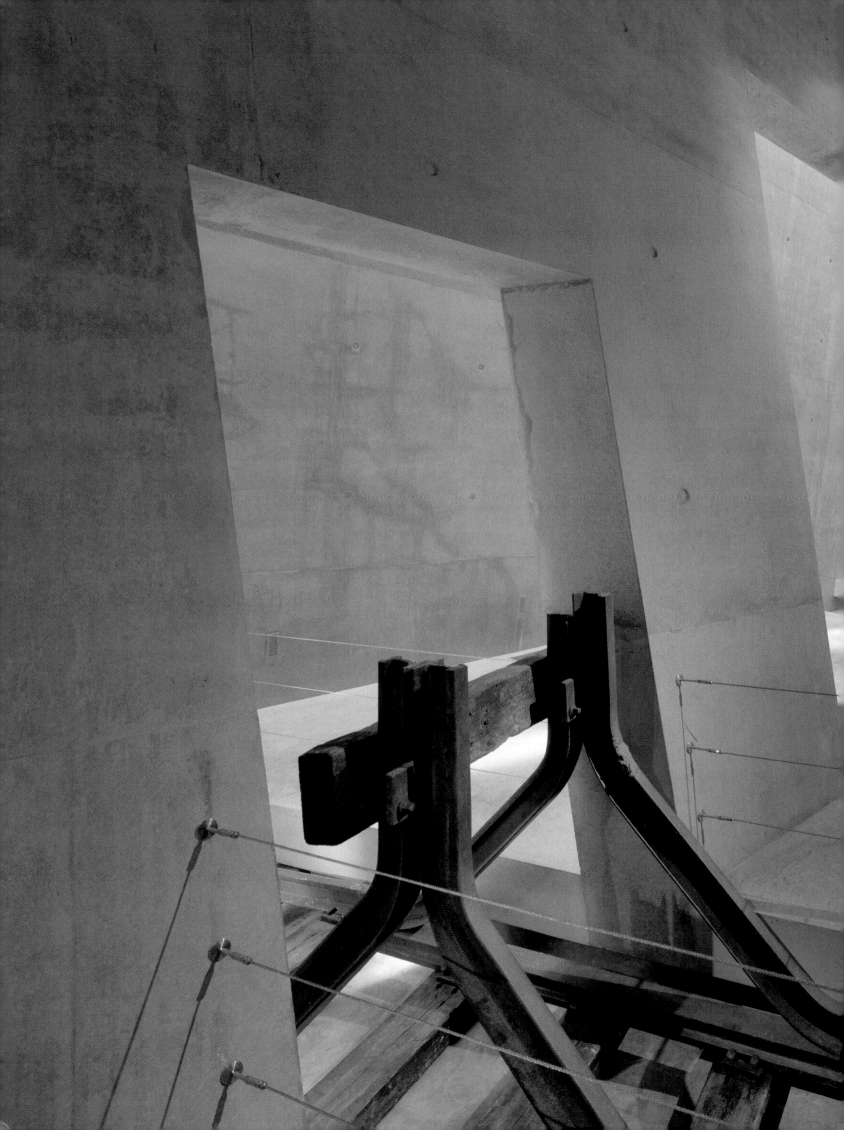

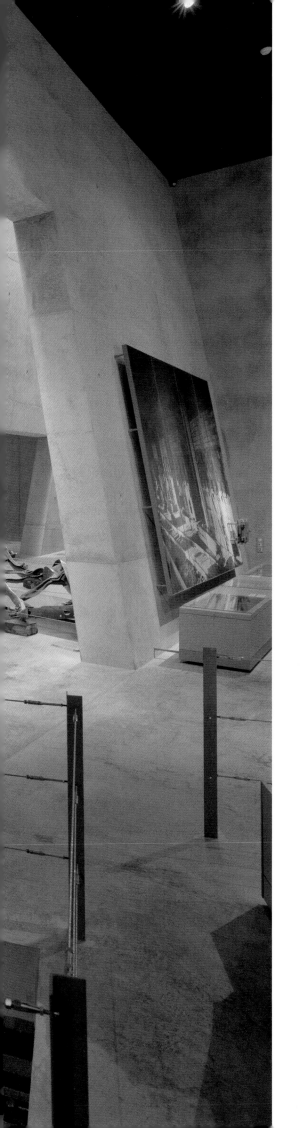
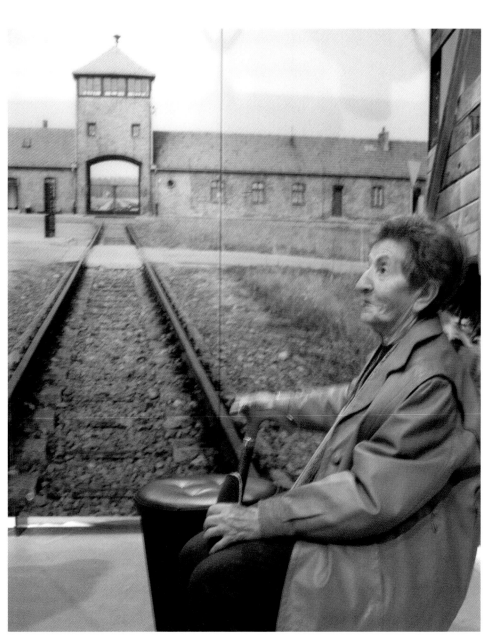

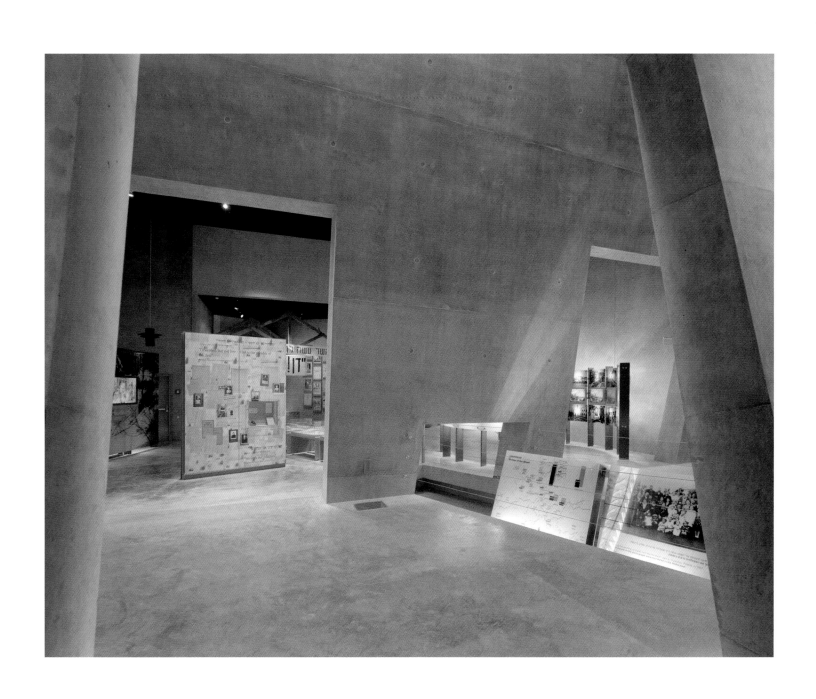

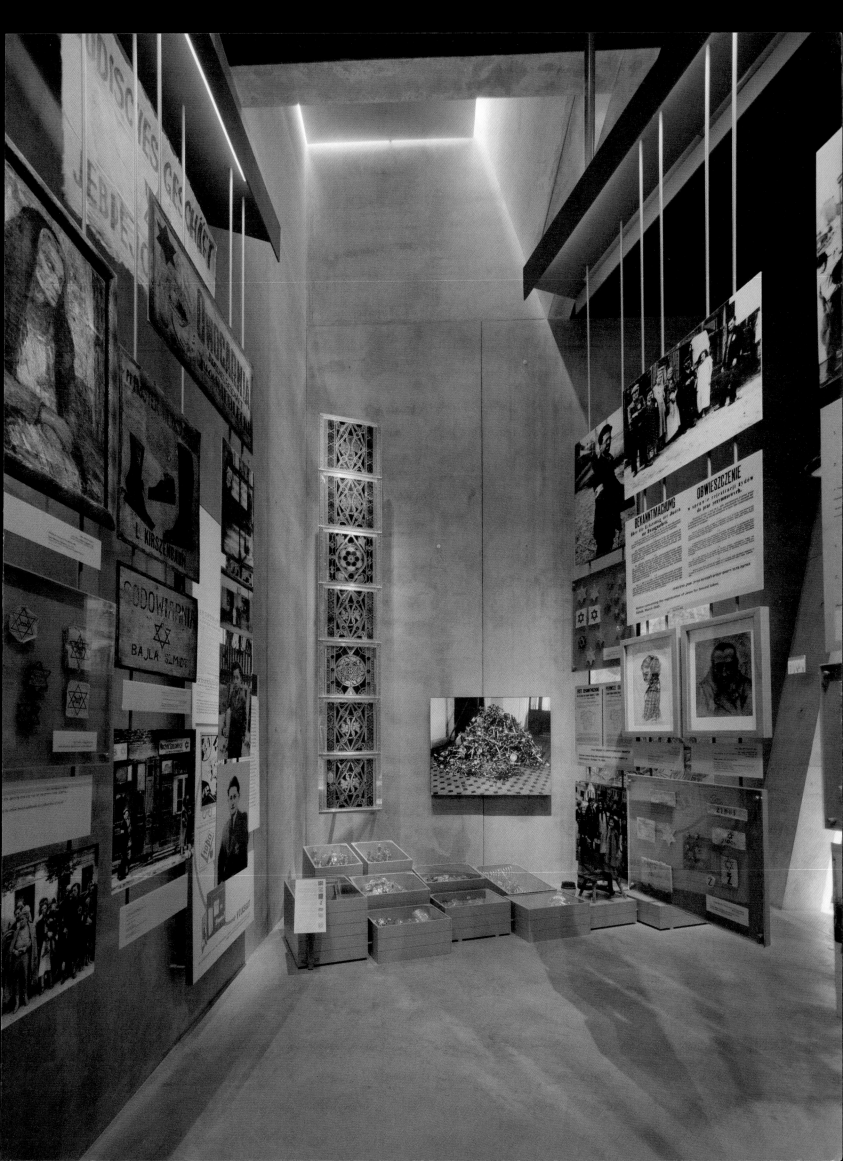

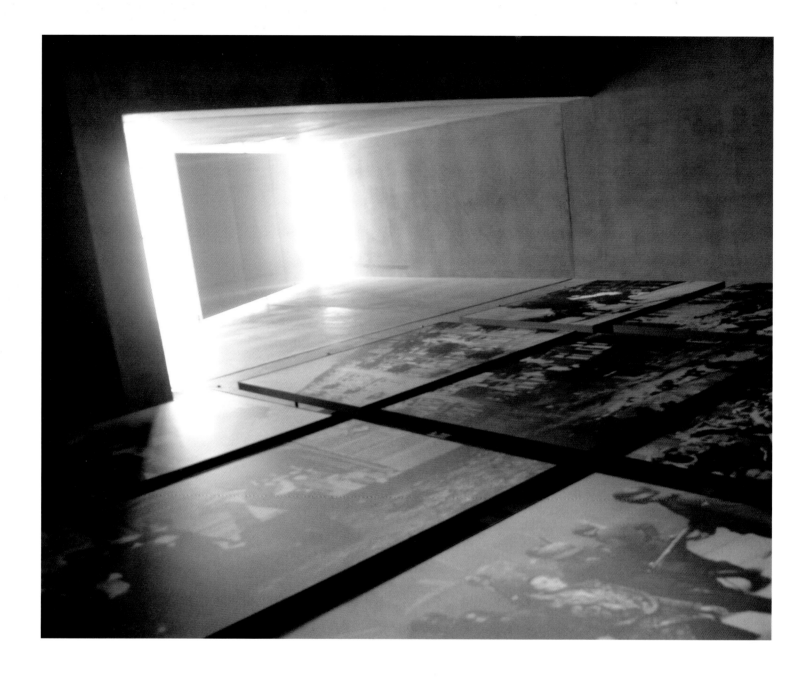

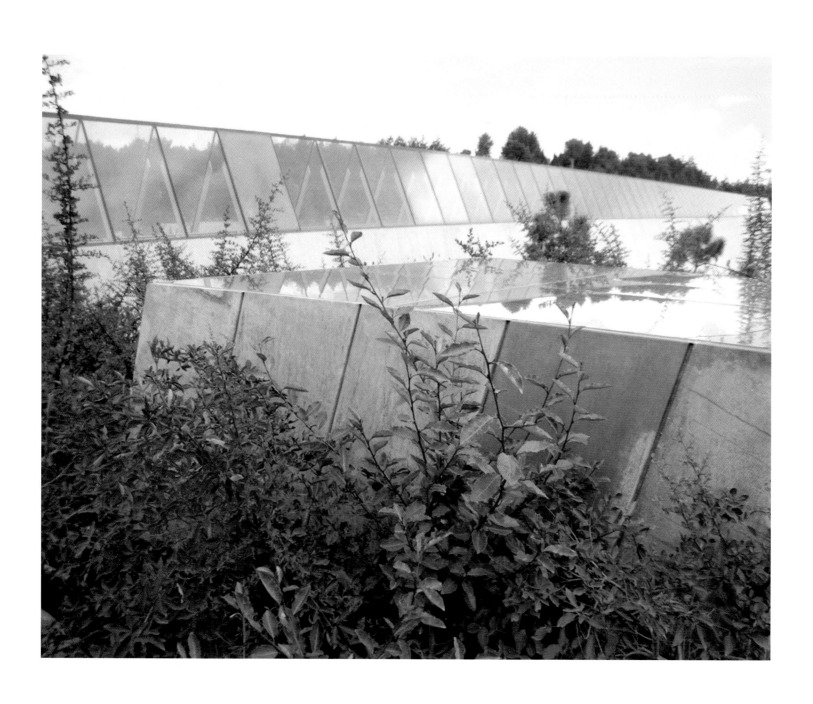

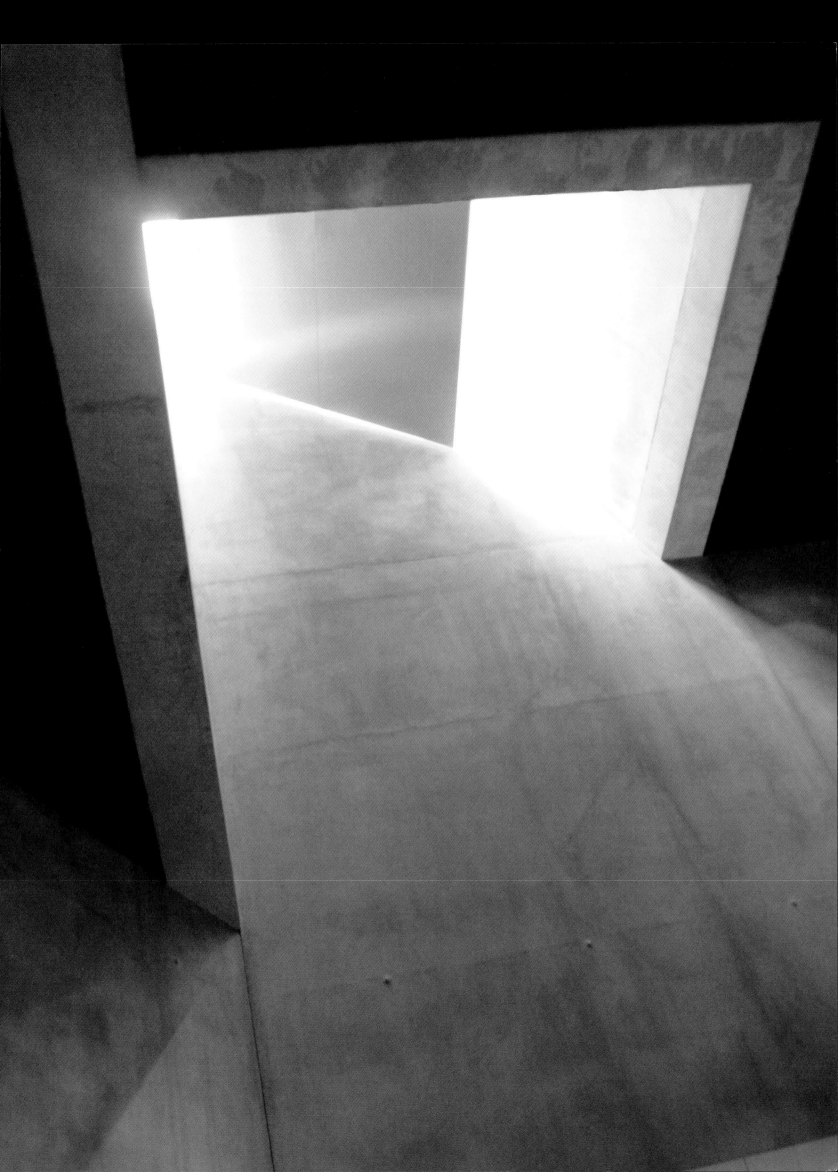

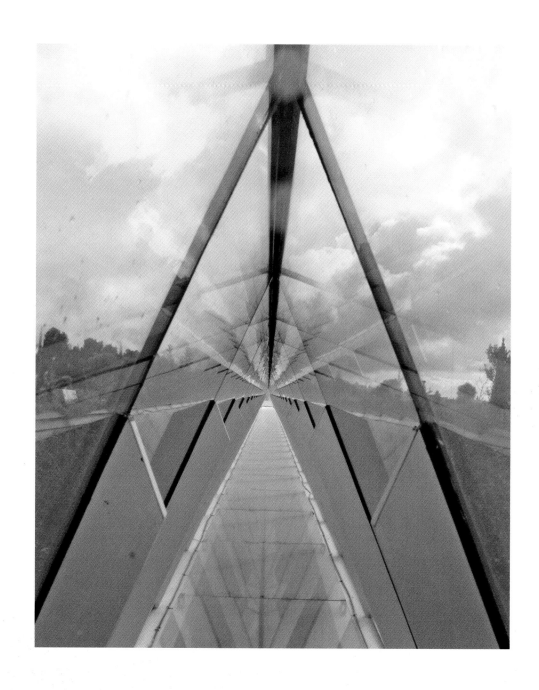

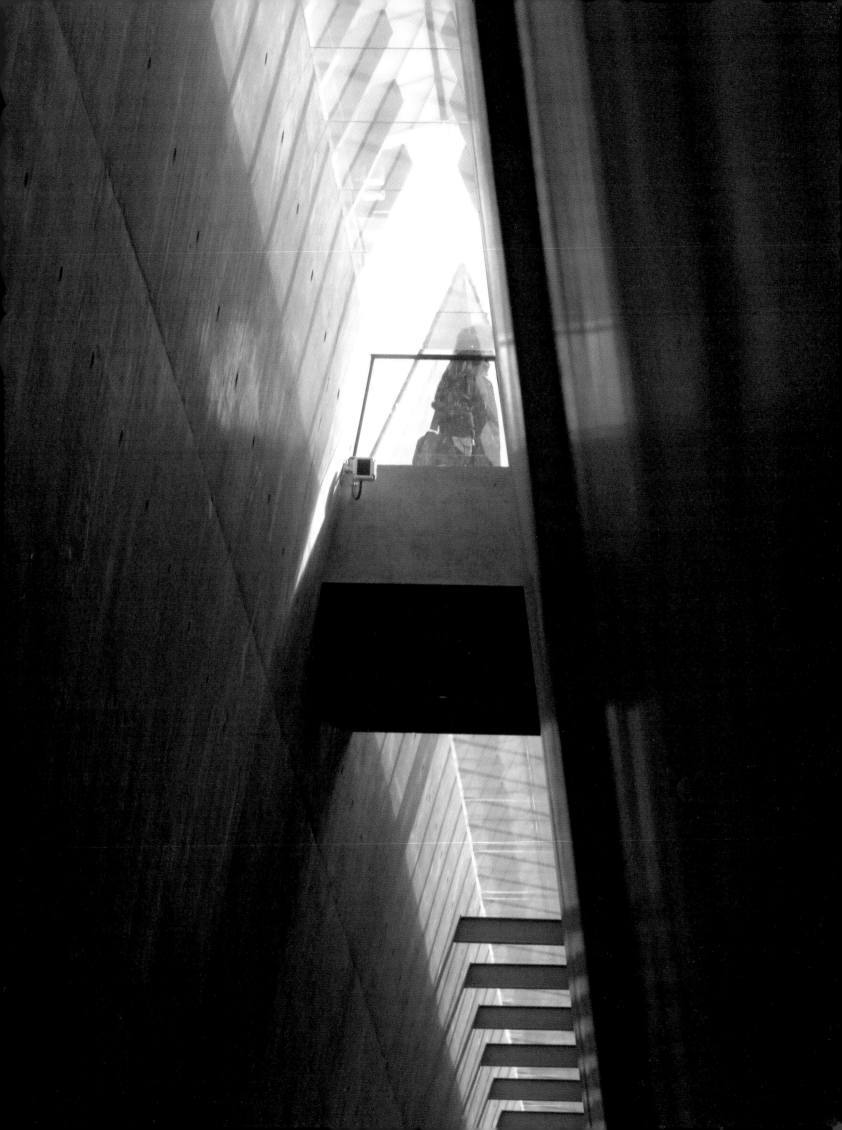

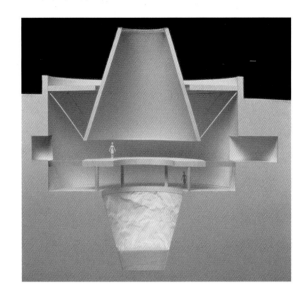

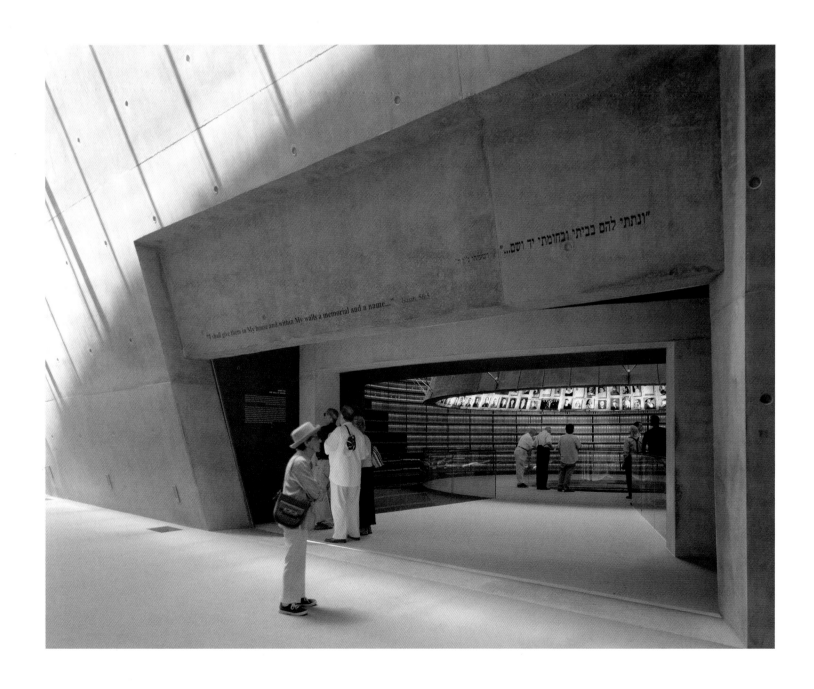

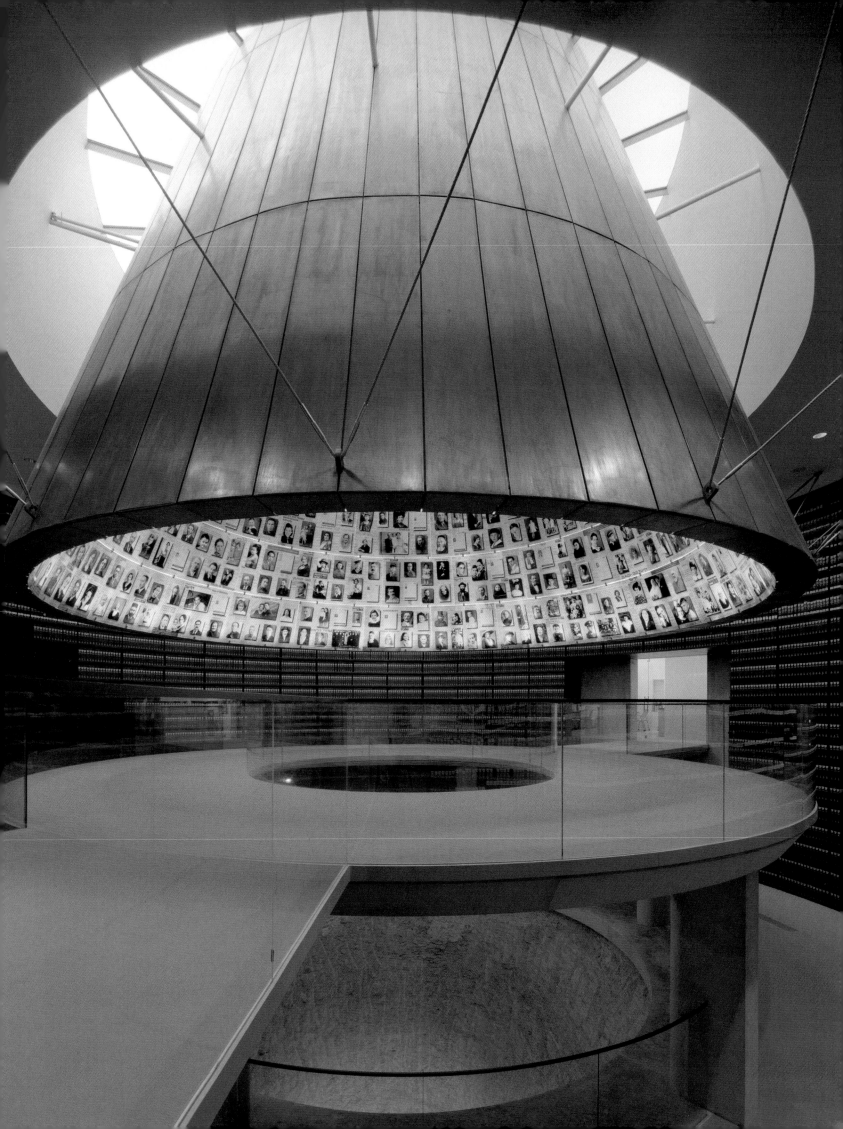

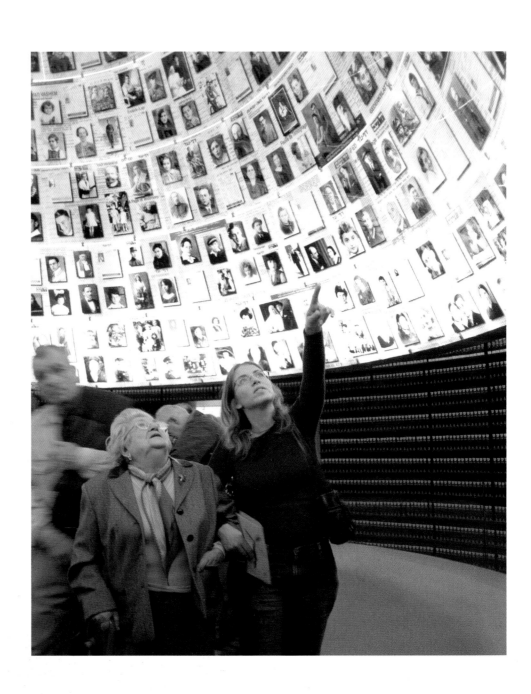

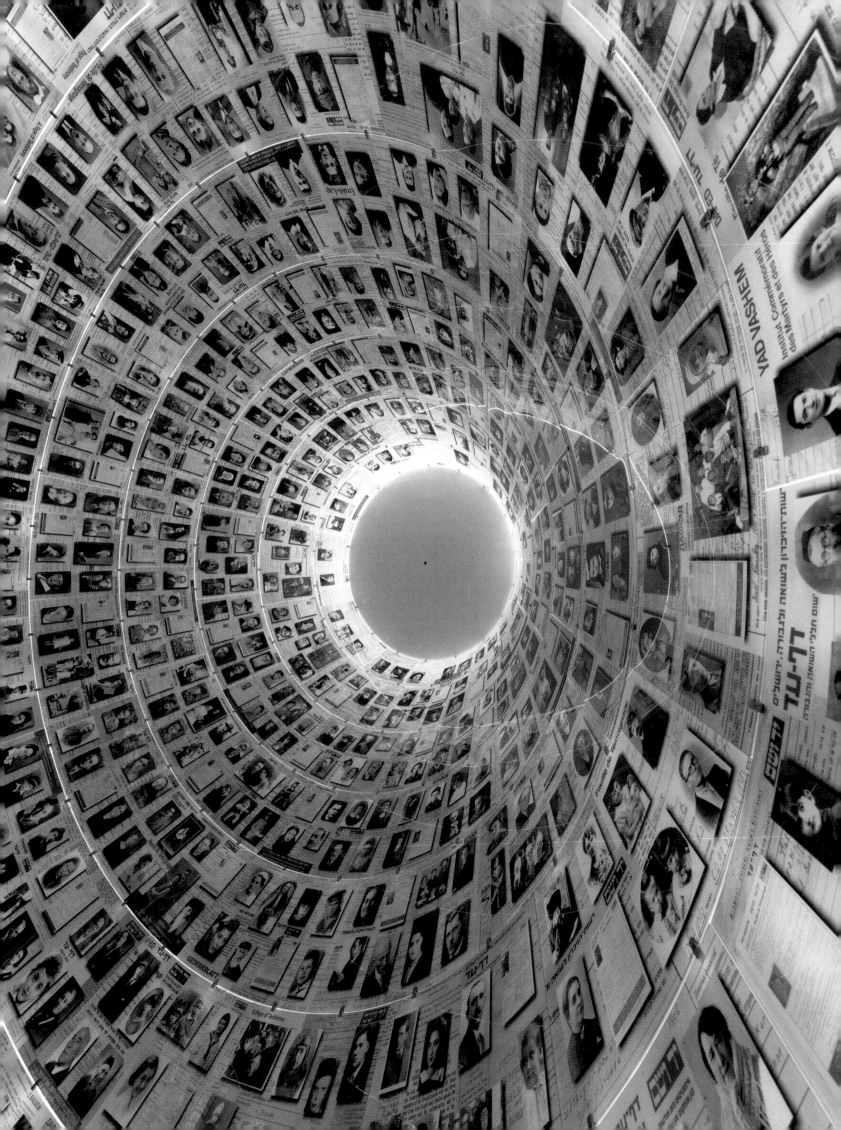

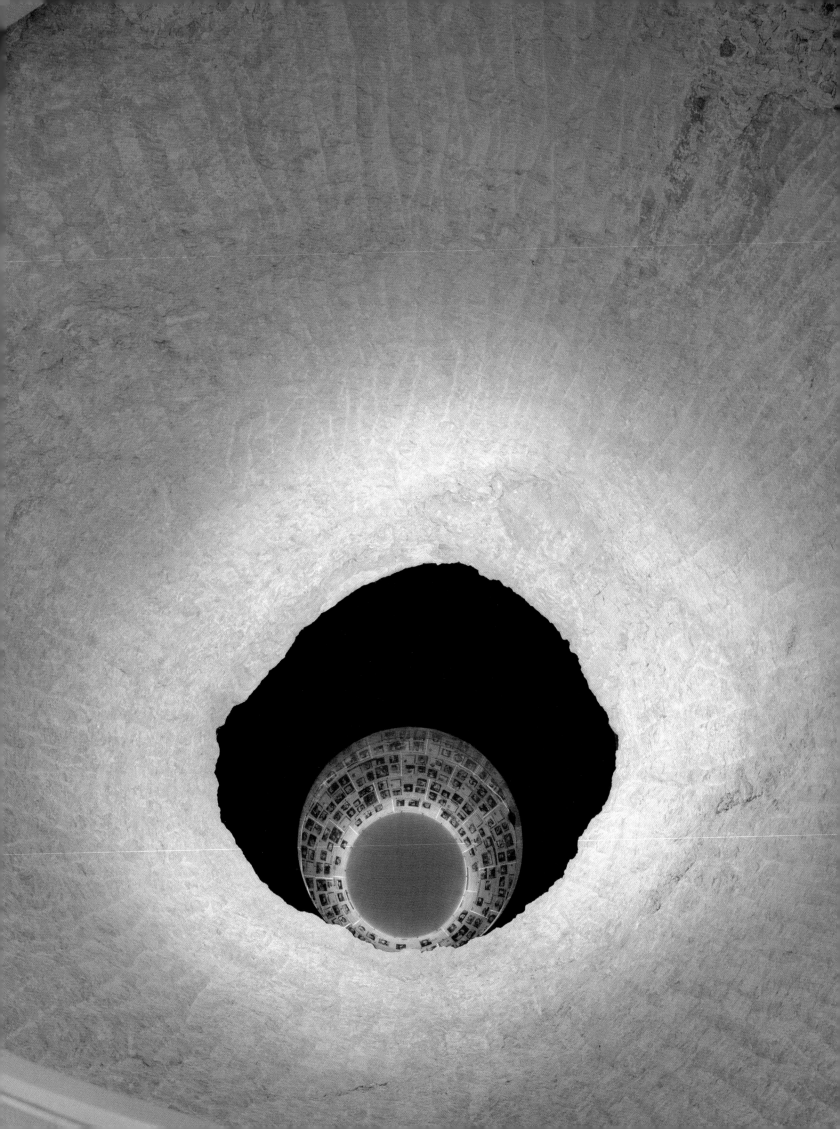

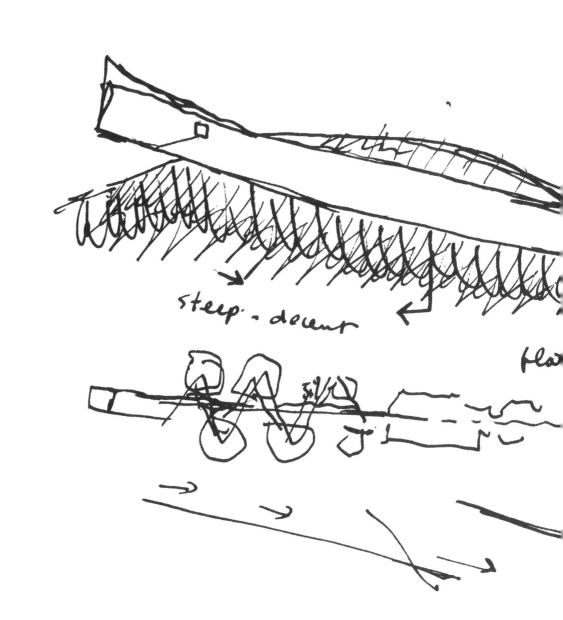

steep - descent

flat

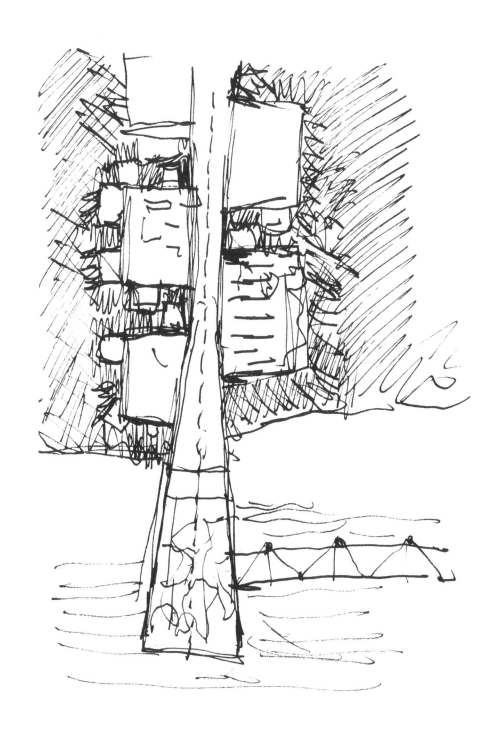

climb
gentle

ter!

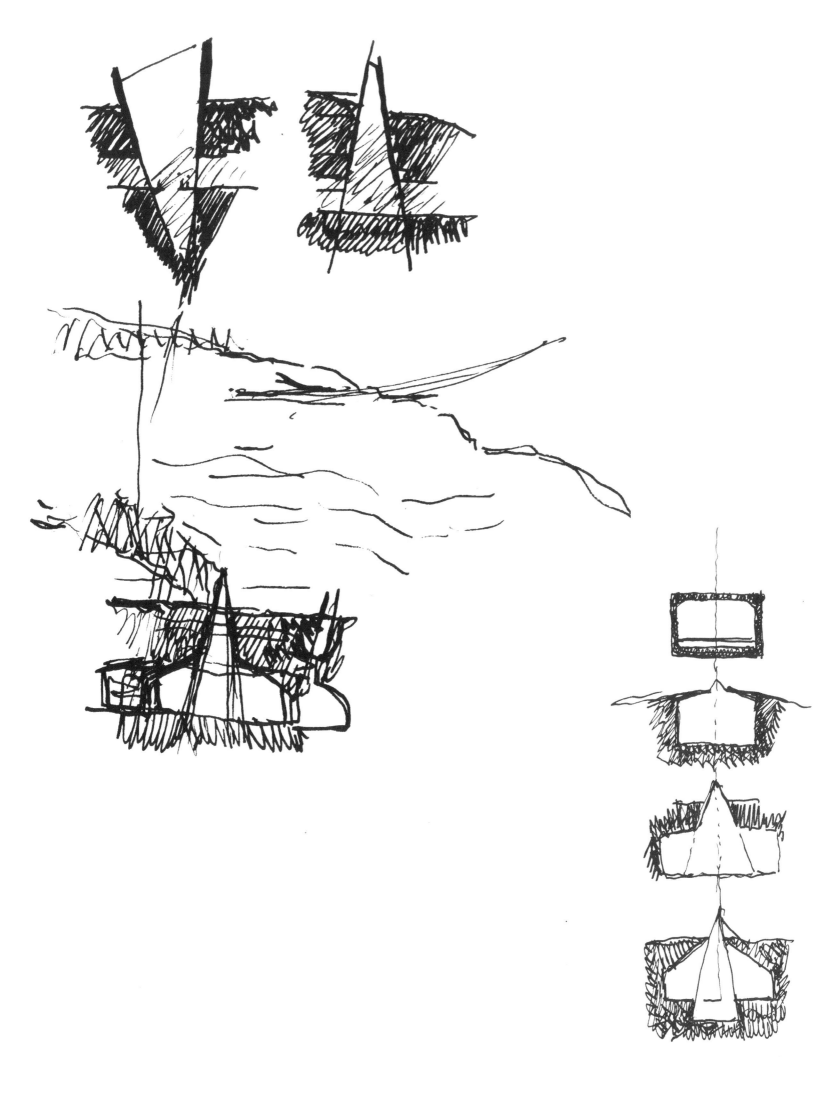

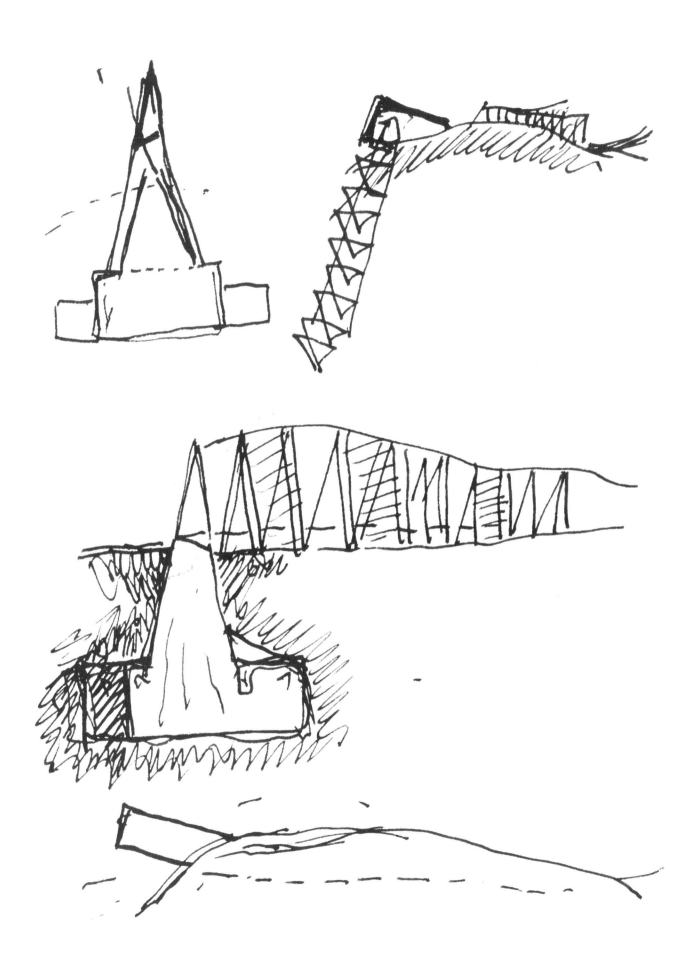

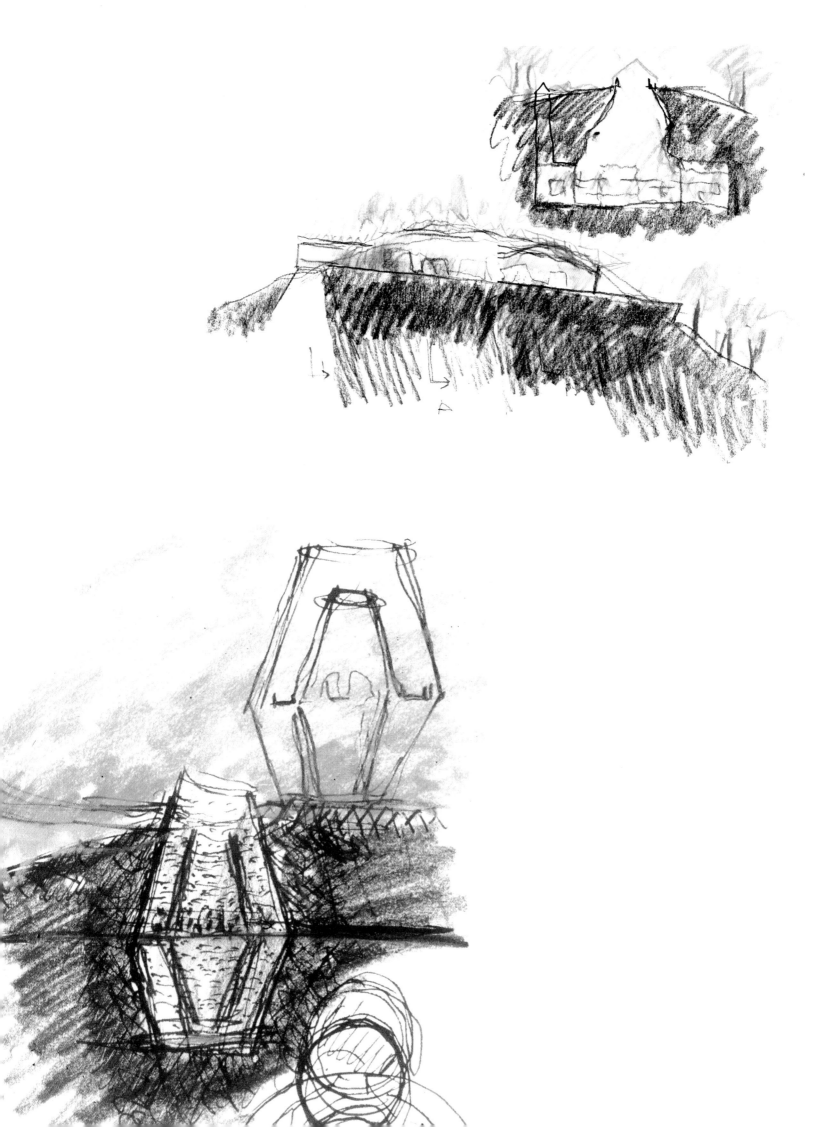

# The Architecture of Memory

Moshe Safdie

Being Sephardic and living in the Middle East, my family lost no one to the Holocaust. Yet it was omnipresent in the culture in Israel, and is part of even my earliest memories.

It is 1944, I am six years old. We have escaped to Jerusalem, to family, to avoid the nightly bombing of Haifa. Yom Kippur, the annual visit to the synagogue: it is time for Yizkor, the prayer for the dead. Bat Sheva, our young nanny, a refugee from Germany, stands in the doorway of the synagogue, neither in nor out, uncertain of the fate of her family (who, she later learned, all perished).

In Montreal, Canada, in 1954, I meet Nina Nucynovich, who will become my first wife. She has recently arrived from Poland via Israel. Born in 1937, she survived the war. Tales of the forest, hidings, and unimaginable cruelty and suffering enter my life.

In Jerusalem in 1973, I meet Michal Ronnen, my future second wife. She is the daughter of Vera Bischitz, a Bergen-Belsen survivor, from a Hungarian family saved by the Kastner deal.

My first professional encounter with Yad Vashem occurred in 1976. At the time I was commuting between Montreal and Jerusalem. "Tolka" Arad, then chairman of the Yad Vashem Directorate, had invited me to design a museum in memory of the children who were murdered. I was given access to the archives and spent days viewing remnants of lost lives. I began to appreciate the nuance of information versus contemplation, confrontation versus meditation. I realized that the visitor emerging from the history museum will already be saturated with information. The Children's Holocaust Memorial must therefore be about reflection.

Entering through a natural archway into a cave, we would descend into the depths of the Mount of Remembrance. In this great underground chamber

a single candle would be made to reflect into space—millions of floating flames—through which we would move, surrounded. Then we would emerge through the mountain to the north, to light, to the view of the Jerusalem hills. The Yad Vashem management reacted with caution and skepticism to my proposal. "People might misunderstand...they might think discotheque." The proposal was shelved.

It took a visit of survivors, Abe Spiegel and his wife, Edita, who lost their two-year-old son in Auschwitz, to resurrect the project.

The Children's Memorial (completed in 1987) was to prove essential preparation for the great task ahead: to rebuild and reconceive the entrance and museum complex at Yad Vashem—including a new reception building, public services, parking, a new Holocaust history museum, galleries for Holocaust art and changing exhibitions, a synagogue, and a hall of names—while preserving the administration building, archives, and school and restoring Ohel Yizkor, the Hall of Remembrance, which opened in 1961.

From applicants worldwide, four architects were chosen as finalists, and a three-stage design competition unfolded. The new program was ambitious: more than 17,000 square meters of new space to be built; the Holocaust museum to be nearly four times larger than the old one, similar in size to its Washington, D.C., counterpart.

The Concept

As I faced the program with its lists of required spaces and walked the site, which I knew so intimately, some thoughts started to become clear. The master plan given to us as a guide called for the transportation drop-off—large enough for fifty buses and hundreds of cars—to be in the forested valley below Yad Vashem. I rapidly concluded that it would not do to replace a pine forest with

asphalt and traffic and require the public to climb to the mount above. I proposed that arriving buses, cars, and pedestrians be accommodated along the existing roads, mid-level in the mount, and that these roads be integrated into a series of landscaped terraces. As significant as this move was to the overall concept, and as obvious as the decision seemed to me, it would take many months to convince the officials at Yad Vashem to agree to it.

Having determined the point of entry, I again faced the mount—and began to contemplate how I might place 4,600 square meters of space on top of it. As is the custom in my office, a model was made of the entire site and blocks representing the program were piled upon the hill. It seemed diminished by the mass of buildings. Moreover, I began to understand the challenge of the topography: from the arrival level midway up the hill, the visitor would have to climb to the hilltop and then descend again.

The breakthrough idea, the one that generated almost every other aspect of the concept, was to avoid building on the hilltop altogether. Instead we would cut through the mountain, penetrating it from the south, extending under, emerging, indeed exploding, to the north. Thus the entire new museum would be underground, with a subtle cut across the hilltop—a narrow skylight coming up for light, a reflective knife edge across the landscape that would disclose the museum's presence.

What form should penetrate the mountain? It must be a wedgelike, prismatic shape, the peak of which cuts through the hillcrest, the triangle resisting the load of the earth above. This spine would be straddled by chambers, with shafts rising from each one, like periscopes through earth and vegetation, for light.

The story of the Holocaust is too terrible, uniquely cruel and shameless in the annals of civilization, to be told in normal "galleries," traditional architectural

constructions with doors, window frames, hardware, and other detailing.
I began thinking of my visits to places created deep in the earth that might
provide insight: Cappadocia, with its underground cities; and the subterra-
nean chamber of Beit Guvrin in the hills southwest of Jerusalem. I also recalled
a photograph that had come my way of the great spaces cut into a stone
quarry in Spain.

But the hard granite into which perfectly formed chambers could be carved
in the Spanish quarry was not the reality of the hills of Jerusalem, with their soft
and geologically unpredictable limestone strata. And so the chambers would
have to be excavated—cut through the mount—then cast in concrete, and earth
replaced atop them. The chambers, lined in concrete against the bedrock,
are like giant burial caves in the Mount of Remembrance.

The *Mevoah*
Before visitors enter the museum, they must be received in an area where
public services and orientation are available. Accommodating thousands
of visitors a day, such services consume space—and yet, again, I did not want
to create a building-like structure as a gateway to Yad Vashem.

---

A stone quarry in Spain

First a demarcation line had to be drawn across the hill, an aqueduct-like screen that would separate the sacred site from the surrounding city. Through this aqueduct, which would bear the inscription "I will put my breath into you and you shall live again, and I will set you upon your own soul," we would emerge into a paved stone piazza facing the *mevoah*, or visitors' center. I first sketched clusters of thick, hollow stone columns supporting a glass-trellised roof—a kind of peristyle at which visitors would arrive. But the stone structure (mandated by Jerusalem zoning) seemed too pretty, too detailed. I wanted greater abstraction, the feel of an archaeological remnant, and slowly it dawned on me that the aqueduct, the *mevoah*, the museum, and the auxiliary structures beyond must all be cast-in-place concrete. Only concrete could achieve a sense of the symbolic extension of the monolithic bedrock, free of joints, mortar, or any other embellishments.

The *mevoah* is thus a framed concrete screen wall, roofed by glass and a delicate trellis. Jerusalem's constant sun breaks into an endlessly changing pattern of shadows, a lacework of dark and light lines, dematerializing all who pass within it. "Did you mean this to evoke the patterns of the striping on the clothing of the concentration camp inmates?" asked a visitor. I responded that each person will create his or her own associations and symbolic interpretations— architecture is not about prescribing what you ought to feel or think.

From the *mevoah*, across a fragile steel bridge with wood-plank floors, we descend toward the museum, entering the prism where it overhangs the mountain.

During the preliminary architect selection interviews I stated that the museum must not be a black box, and that the exhibits and architecture must resonate and reinforce each other. The dialogue that ensued between curator, exhibit designer, and architect was intense.

For example: The prism cuts through the mountain, the "light" always visible at the end of the tunnel. The clients asked, How do we induce the flow of the public through the storyline as it unfolds chamber by chamber, chapter by chapter? How do we discourage visitors from taking shortcuts by passing the chambers? I responded that we will cut channels in the prism floor, as if an earthquake ripped it apart. These canals filled with artifacts will force the movement diagonally through the storyline.

Visitors enter facing south, confronted by a giant opaque concrete wall— the prism's triangular end. Two hundred meters to the north, they exit into the light. How can the first chapter introduce and accommodate in this unusual space the story of the communities, the life and cultures, of European Jewry that were destroyed? I explained that Michal Rovner's breathtaking "scroll-film" will fill the giant triangle with images of a bygone civilization. Thus we will have a window to the past (south) and a window to the future (north).

The curators asked, How shall we exhibit light-sensitive artifacts, videos, and films within the large concrete chambers punctuated with shafts of light from above? I told them that Dorit Harel's "architecture within architecture," a series

Reinforcing steel and post-tensioning cables being laid prior to the pouring of concrete

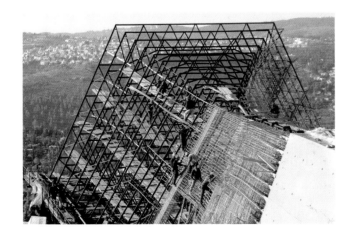

of volumes, walls, and showcases, will inhabit the halls, ordered by their own autonomous geometry, contrasting with the orthogonal geometry of the structure.

I was determined to cast the entire museum monolithically, jointless, unadorned—without any exterior waterproofing or cladding, nor any interior insulation or finishes. I wanted just the basic structure—concrete walls and floors, and glass to let the light in from above. It would take many experiments, mock-ups, novel engineering techniques (borrowed from bridge building), and a dedicated contractor to realize the building. The stainless-steel buttons that conceal the post-tensioning anchors at both ends of the prism are visual testimony of the ingenuity involved.

The Hall of Names
The new Hall of Names was to occur at the end of the series of ten exhibition chambers. It would be the repository for the Pages of Testimony that have been completed for the three million known Holocaust victims. The Hall of Names is thus both an archive and a memorial, an especially sacred place within the sacred site of Yad Vashem.

I remember the meeting in which Avner Shalev, the current chairman of the Directorate and chief curator of the museum, described the hall's component parts. There was a large blackboard in the room, and I began sketching. First I drew the mid-level—the floor level of the museum, where the public enters. Then, wrapping around a circular platform, I drew a great cylinder, into which I placed the witness pages—a shaft of names surrounding the public. Remembering we were underground, I sketched a suspended cone extending upward to the light, its surfaces a palette over which photographs of the faces and names from the witness sheets would be displayed. We paused briefly. The scheme seemed incomplete; something was missing. A few moments later I returned to the board and drew another cone, this one inverted, a cut into

the bedrock ten meters deep, down to the water table, in memory of the people whose names we shall never know. I had never experienced designing so spontaneously and in public. The Hall of Names seemed to design itself. Four years later it was realized exactly as that first blackboard sketch.

From the outset of the process I felt burdened by the knowledge that the last chapter of the museum, the unwritten chapter, is the most difficult of all. This was apparent in every Holocaust memorial museum I had visited. After the buildup of Nazism, after the death camps, the resistance, the inexplicable dehumanization and random death—after the documentation of a black moment in history—then what?

Years before, designing the Children's Memorial had given me an inkling of the power of emerging into light. It meant that life prevailed. For the new museum, cutting through the mountains and bursting northward, dramatically cantilevering the structure over the Jerusalem pine forest to provide views of the hills beyond took this life-affirming experience to another level. To stand on the extended terrace, the side walls of the prism curving away from the site seemingly into infinity, and see the fresh green of the recently planted forest with its great sense of renewal and the urbanizing hills beyond is to understand that, indeed, life prevailed. We prevailed.

It is this moment in the museum that existentially differentiates Yad Vashem from every other Holocaust museum and memorial, even from the archaeological remnants of the crematoriums of Auschwitz-Birkenau and Dachau.

"Why should the central Holocaust museum be in Jerusalem? Why not in Eastern Europe, where it occurred?" I was asked this question during a presentation at the Goethe Institute in Boston. "Because many of the survivors and their offspring are living there," was my spontaneous response.

The visit to Yad Vashem does not end on the terrace of the museum. In many ways it would have been best if this were so. Yet there are more program components. There are galleries for Holocaust art and changing exhibitions, the synagogue, Ohel Yizkor, and the path across the ridge of the mount to the Children's Memorial. People can further explore the site at the Memorial to the Deportees (built in 1995) and the Valley of the Communities (1992). Then they return to the *mevoah*, through which they depart.

The Courtyard

Following the visit to the museum, I felt that what was needed was a place of decompression—a pause.

The sunken courtyard, enclosed by battered concrete walls and open to the sky, is the inverse of the *mevoah*. Within, an orchard of shade trees and concrete benches provide a place of rest. The two galleries, the synagogue, and a café surround the courtyard on its four sides, each buried in the ground and invisible except for their gateways within the courtyard's concrete walls.

Children's Holocaust Memorial, 1976–87

Memorial to the Deportees, 1995

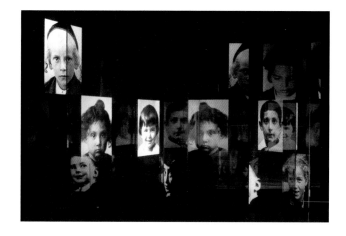

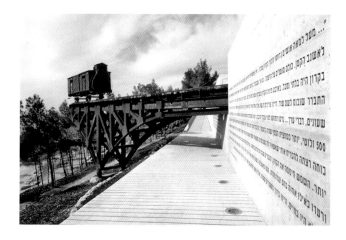

From the courtyard, the public ascends (the only change of level during the entire visit) by stair, escalator, and elevator to Ohel Yizkor, and across the pastoral landscape (by the landscape architect Shlomo Aronson) to the Children's Memorial.

No design I have ever undertaken was so charged with symbolic associations. It seemed that every move, form, shape, and sequence elicited multiple interpretations and endless debate. Now that the public has possessed the complex, I am amazed at the diversity of interpretations and reactions. When I am there I often become a voyeur, watching visitors' reactions and listening to their conversations. I have always wondered if architecture is capable of evoking the same emotions that we experience listening to music. At Yad Vashem I am constantly aware of how intensely personal the feelings provoked are, and how individual and particular. It is at these moments that I feel architecture can, however rarely, move us as deeply as music can.

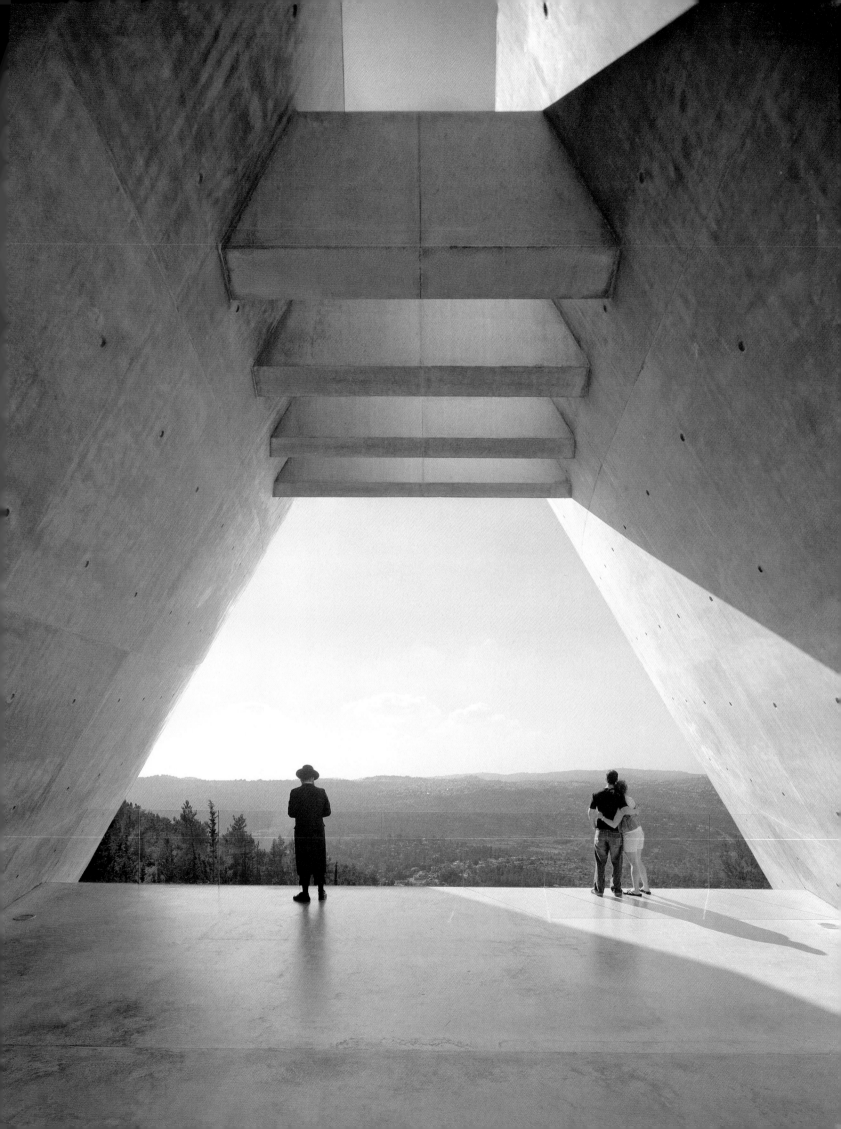

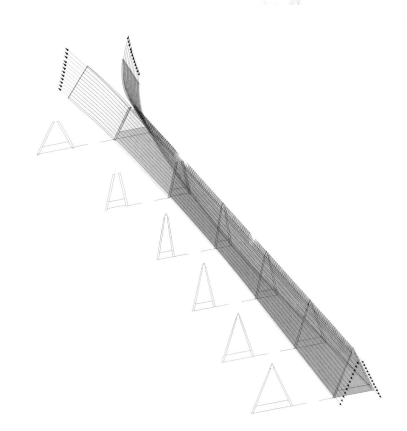

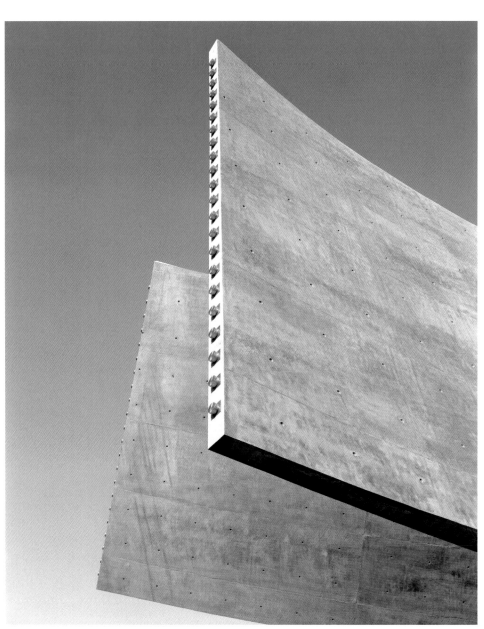

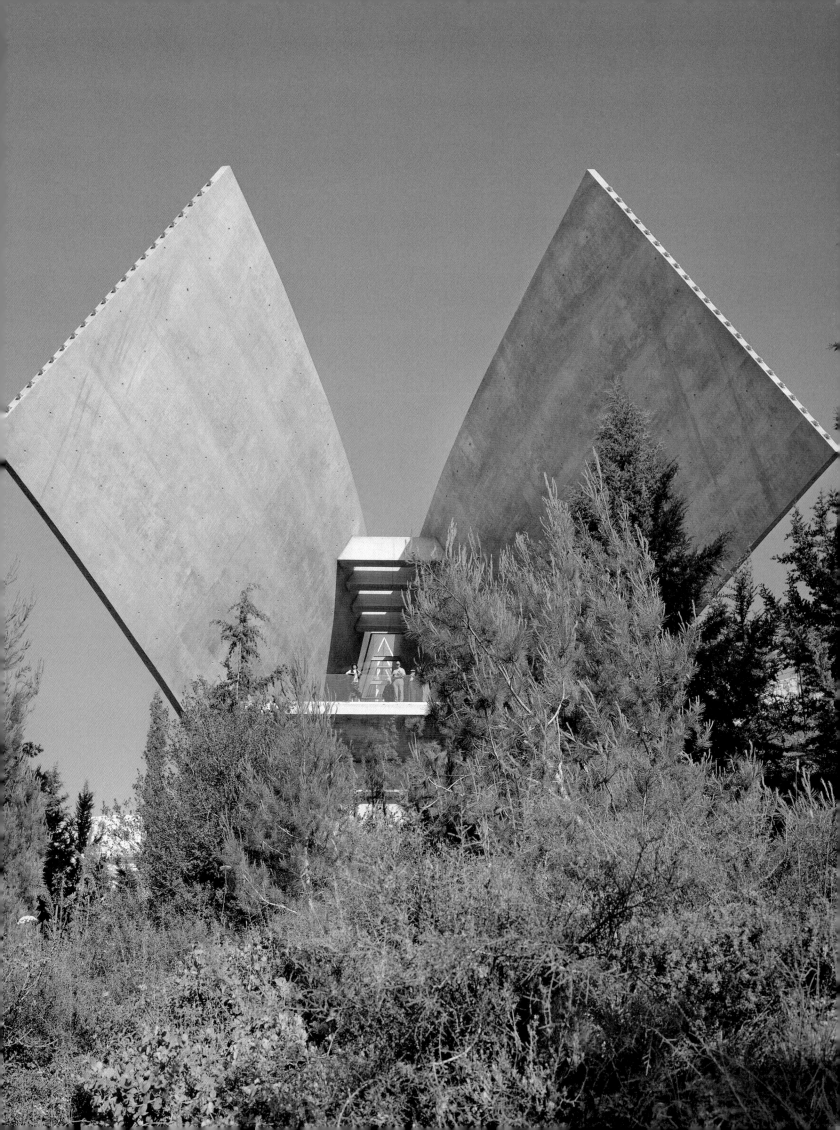

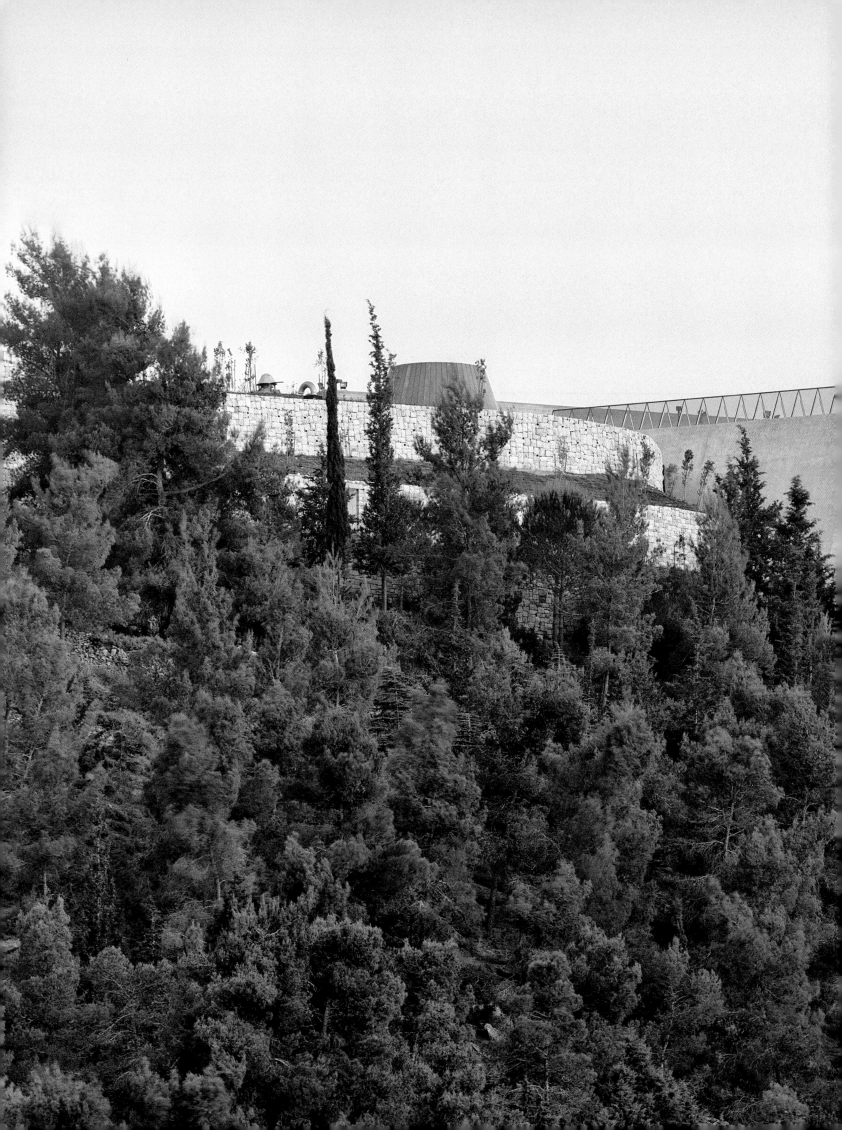

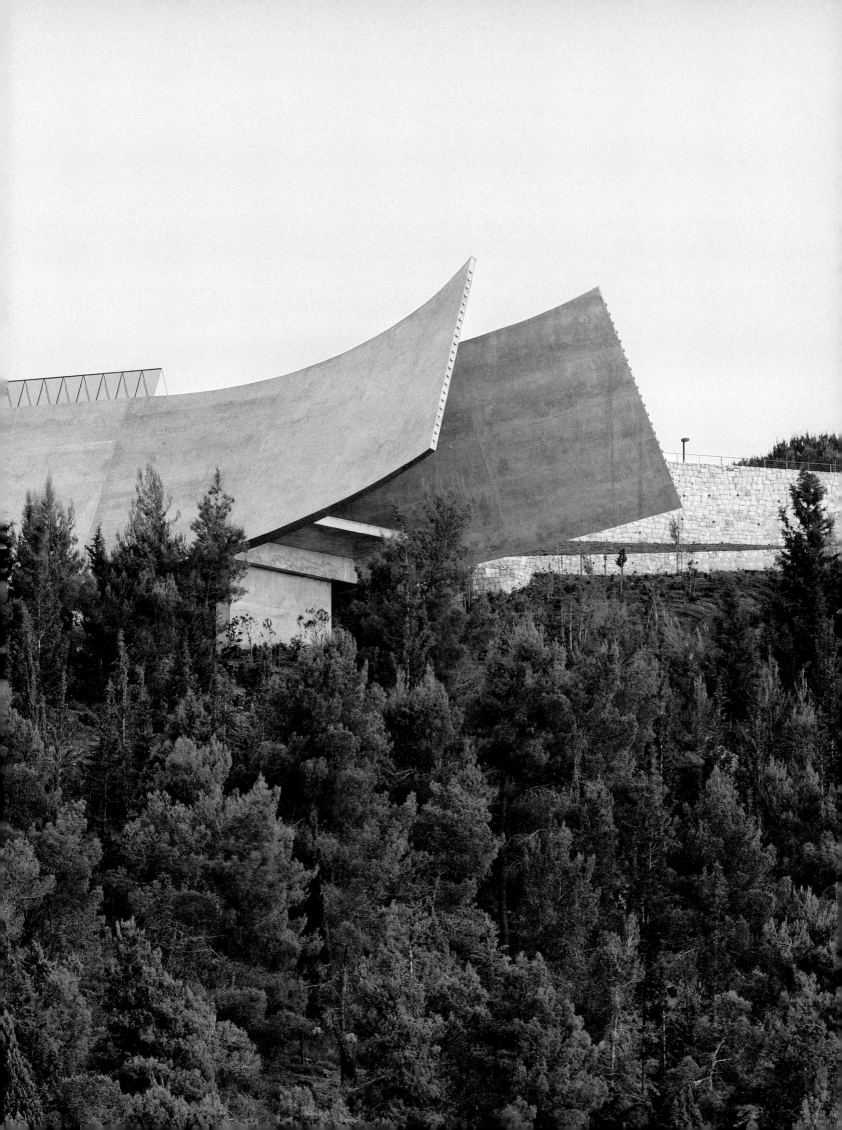

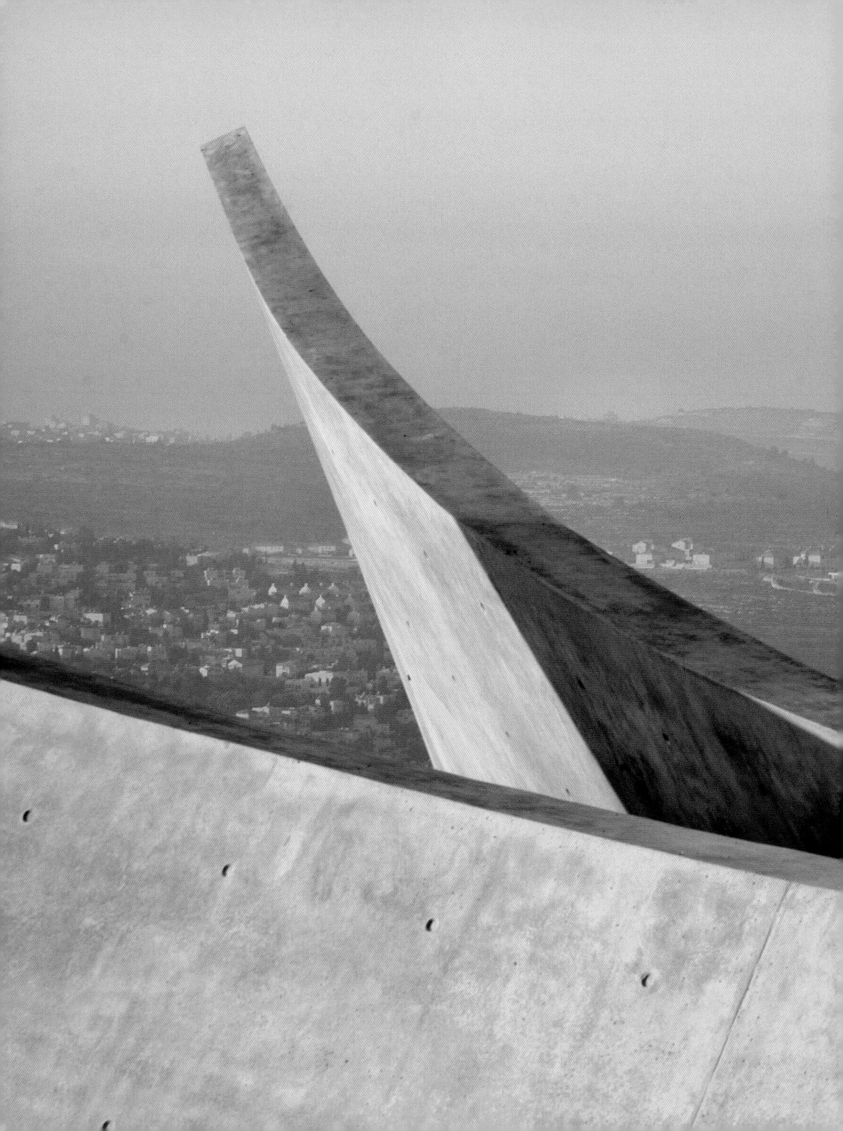

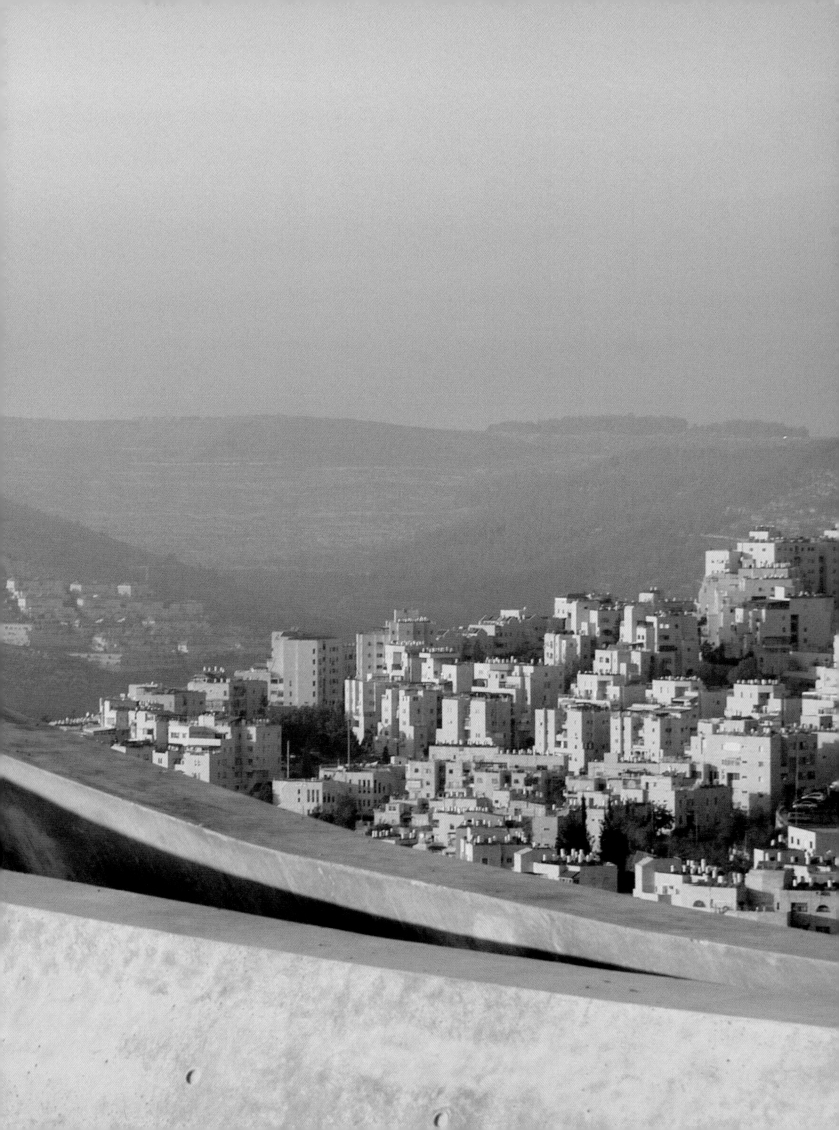

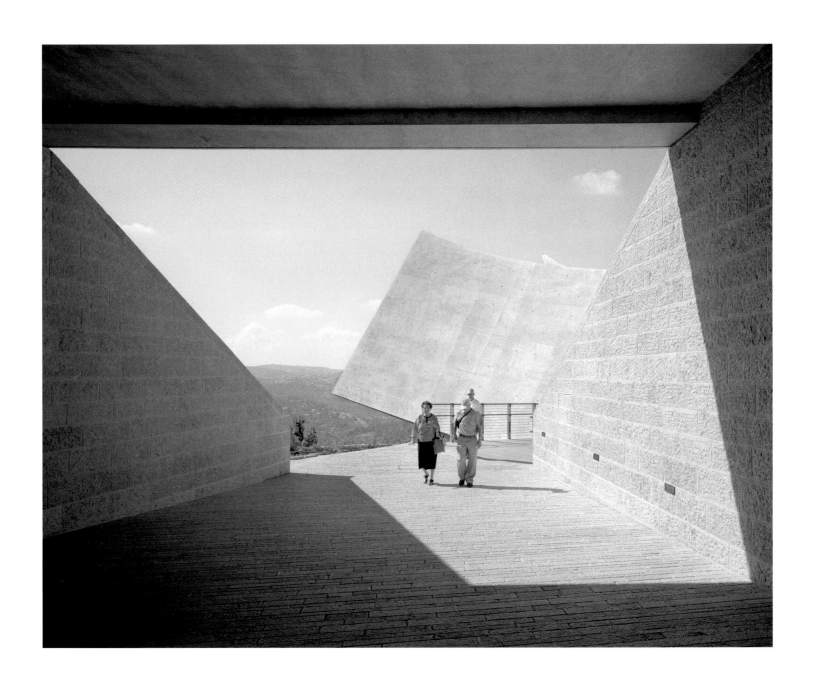

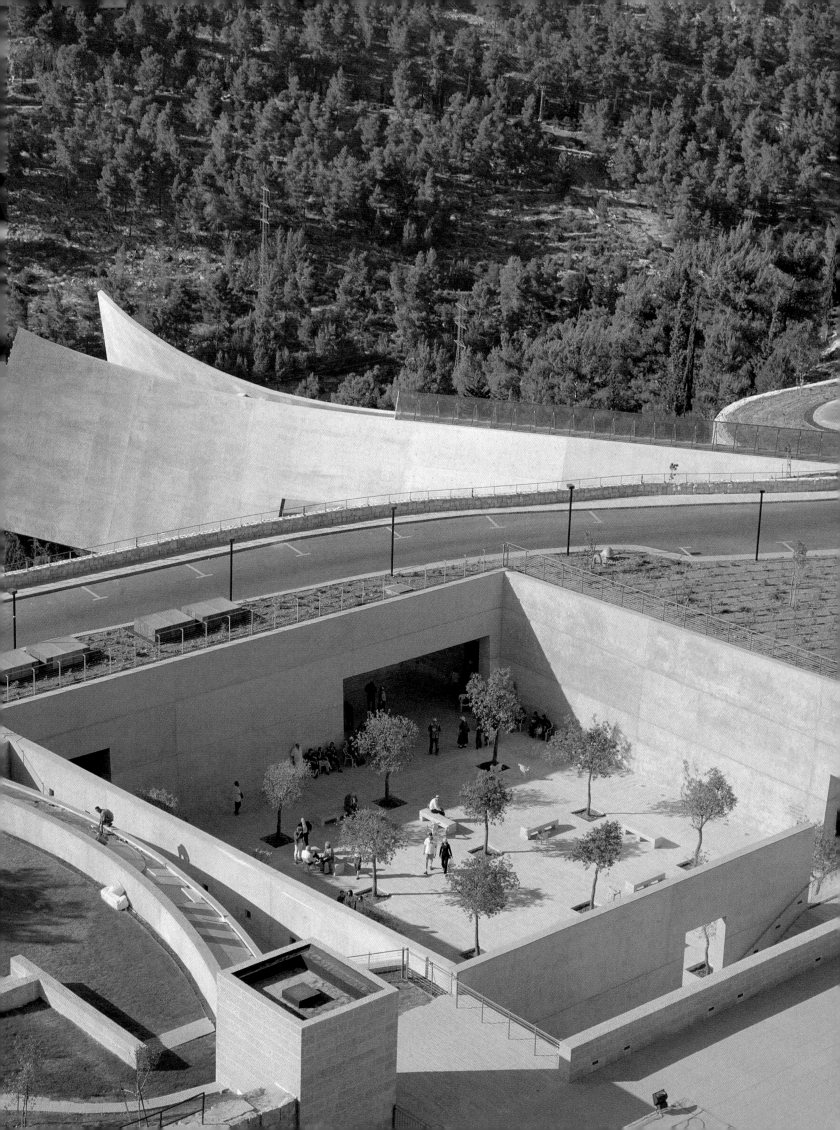

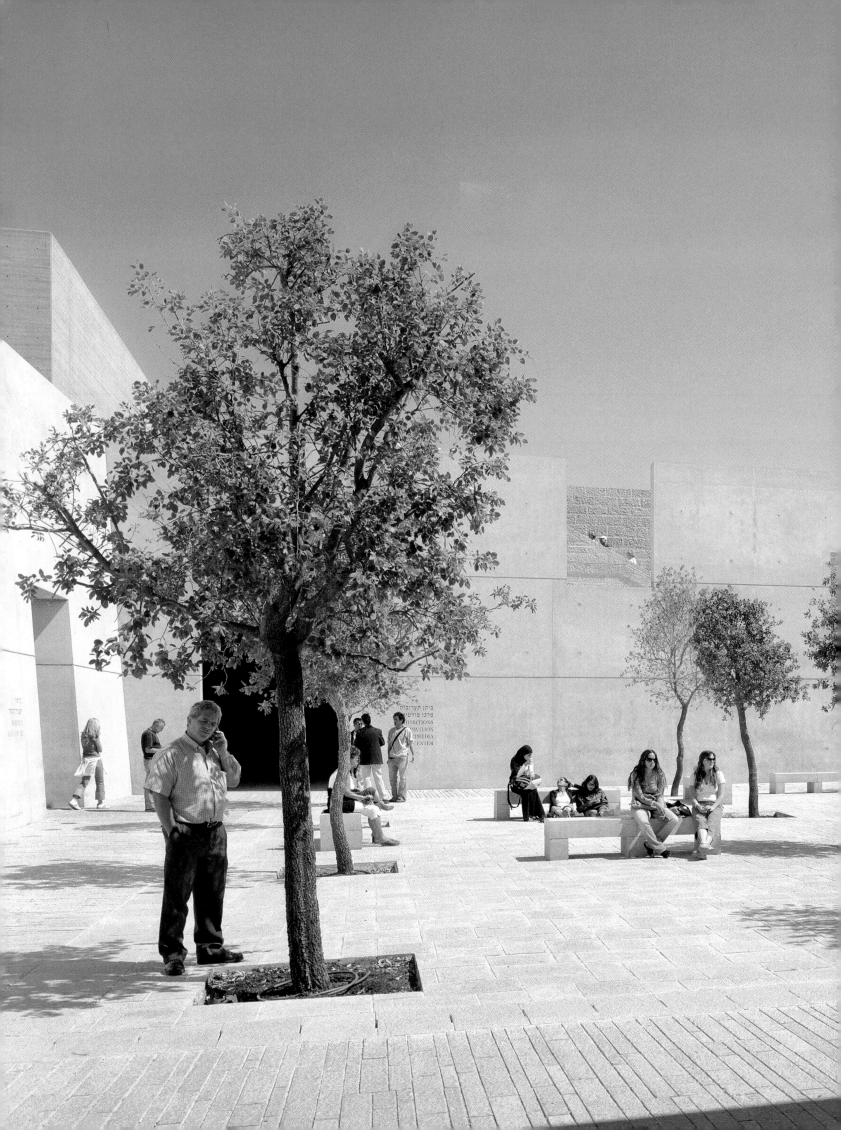

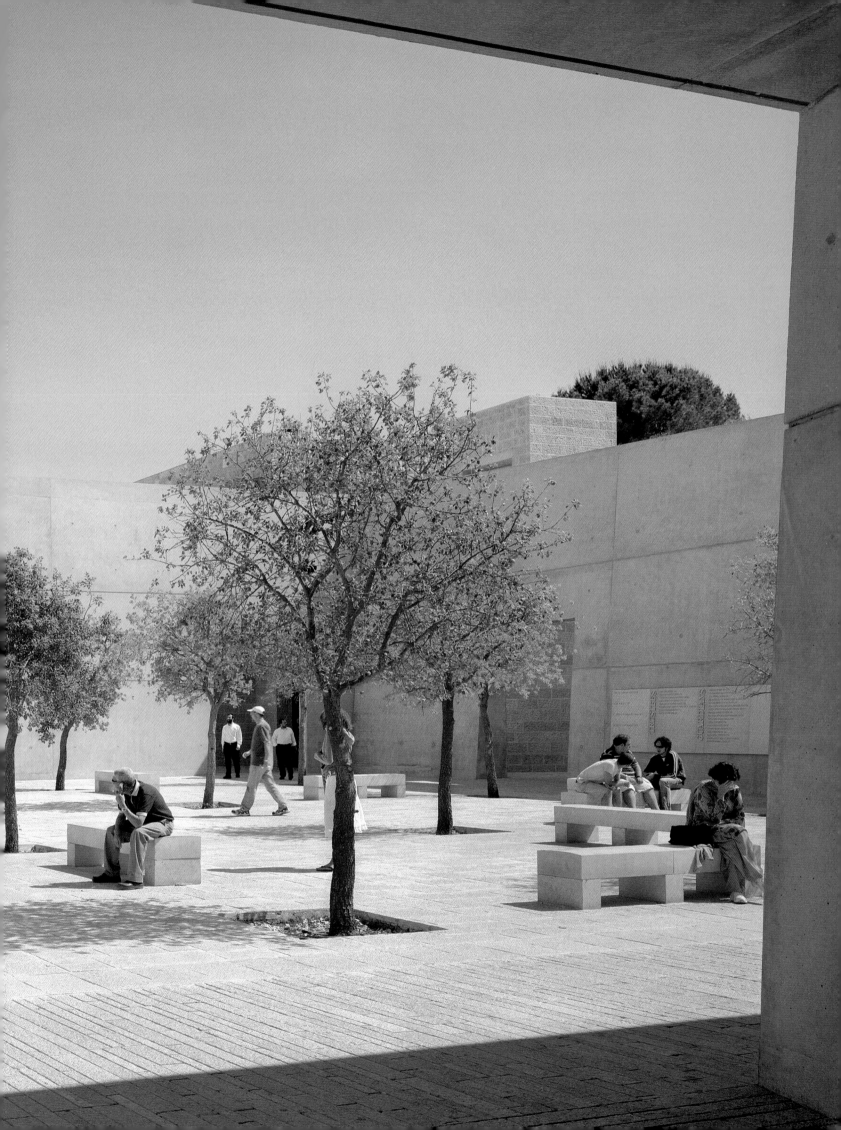

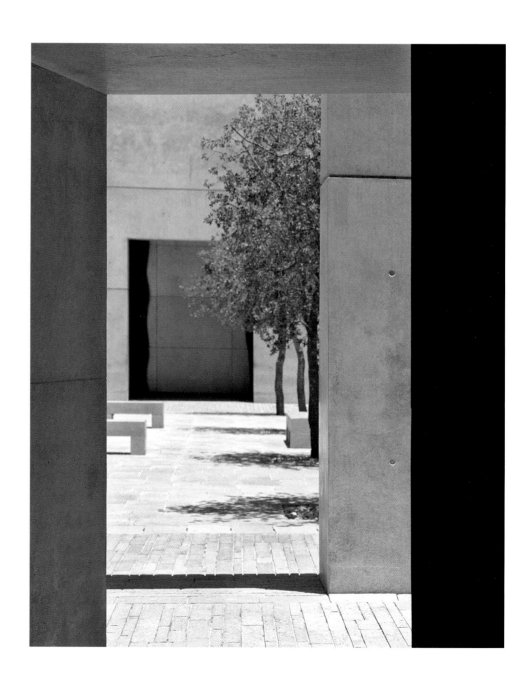

Synagogue

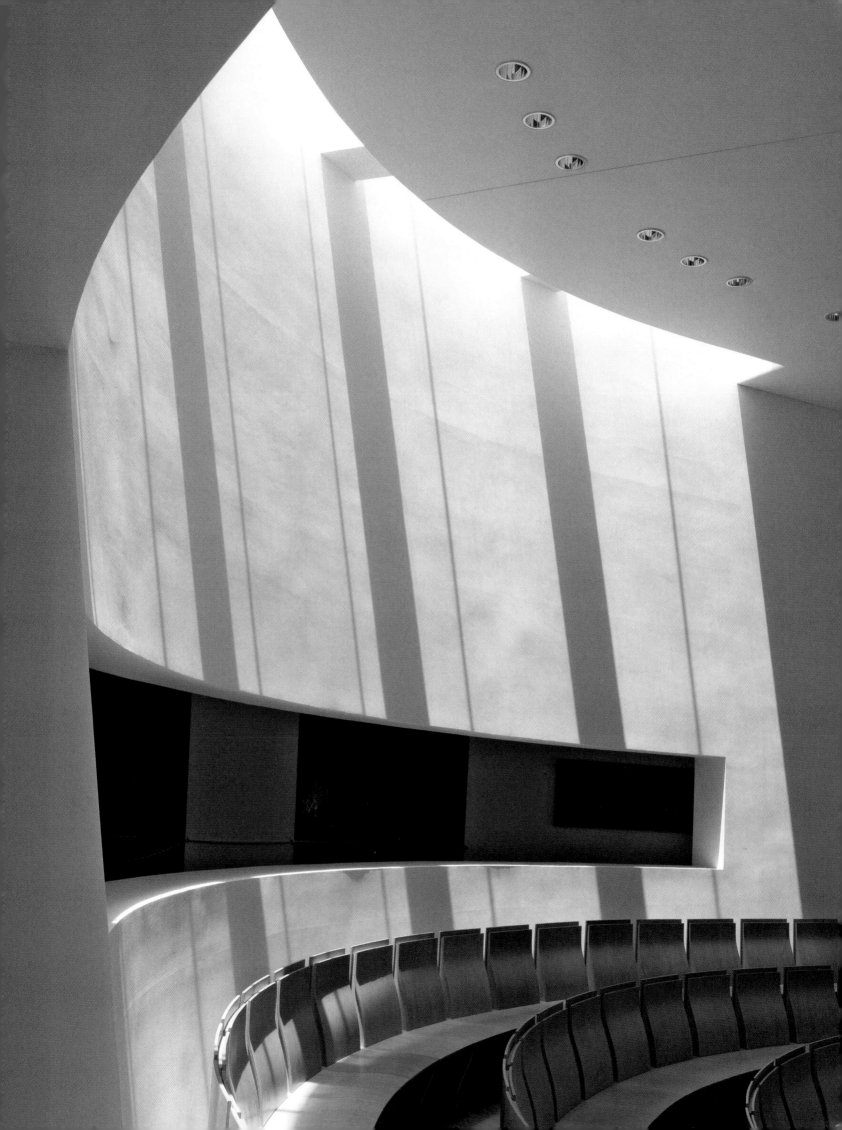

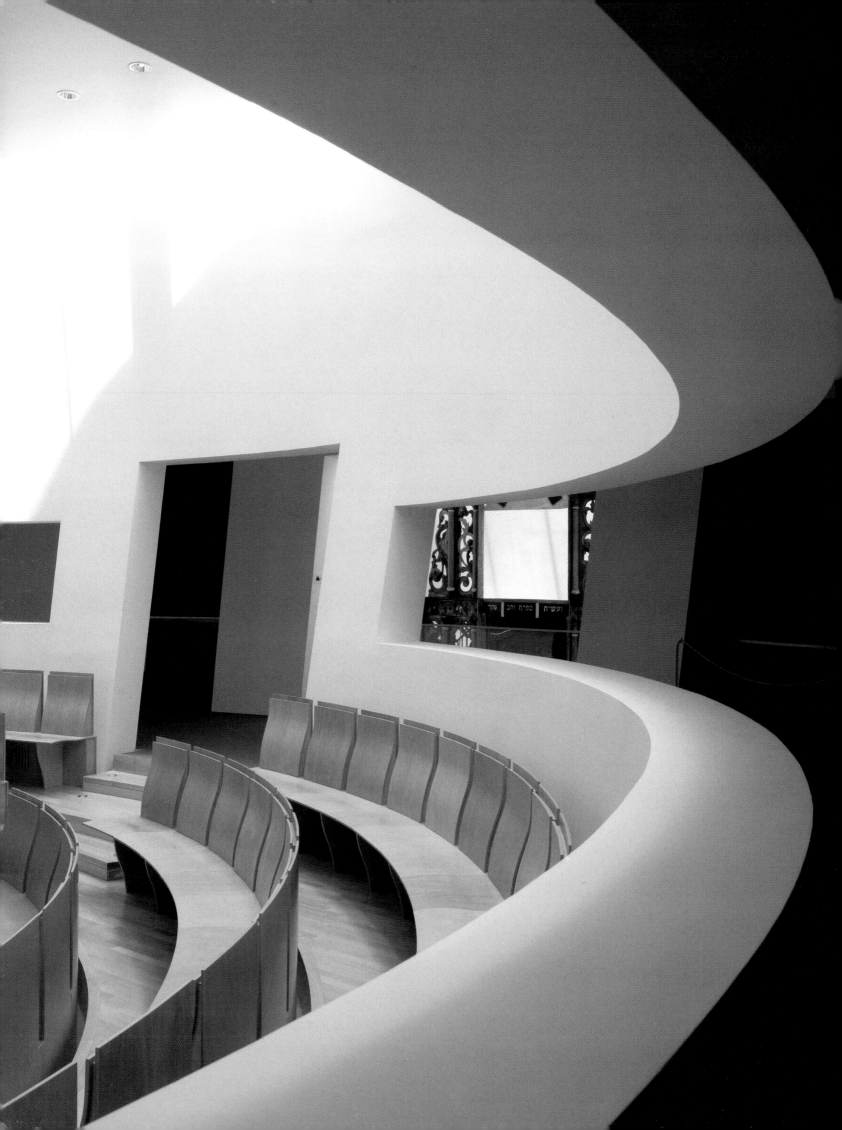

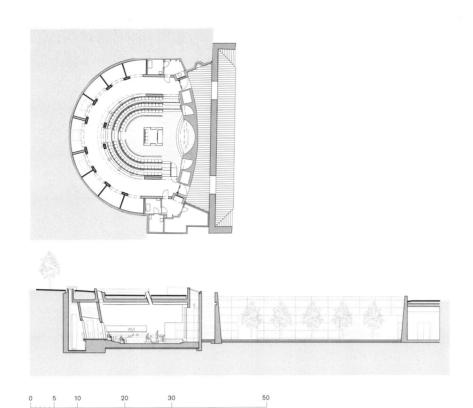

0    5   10      20      30           50

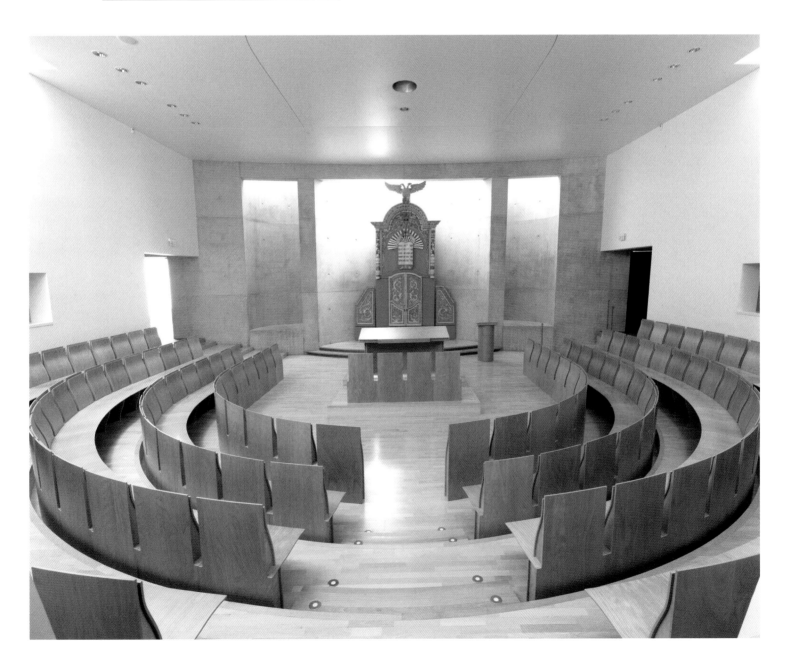

Memorial to the Deportees

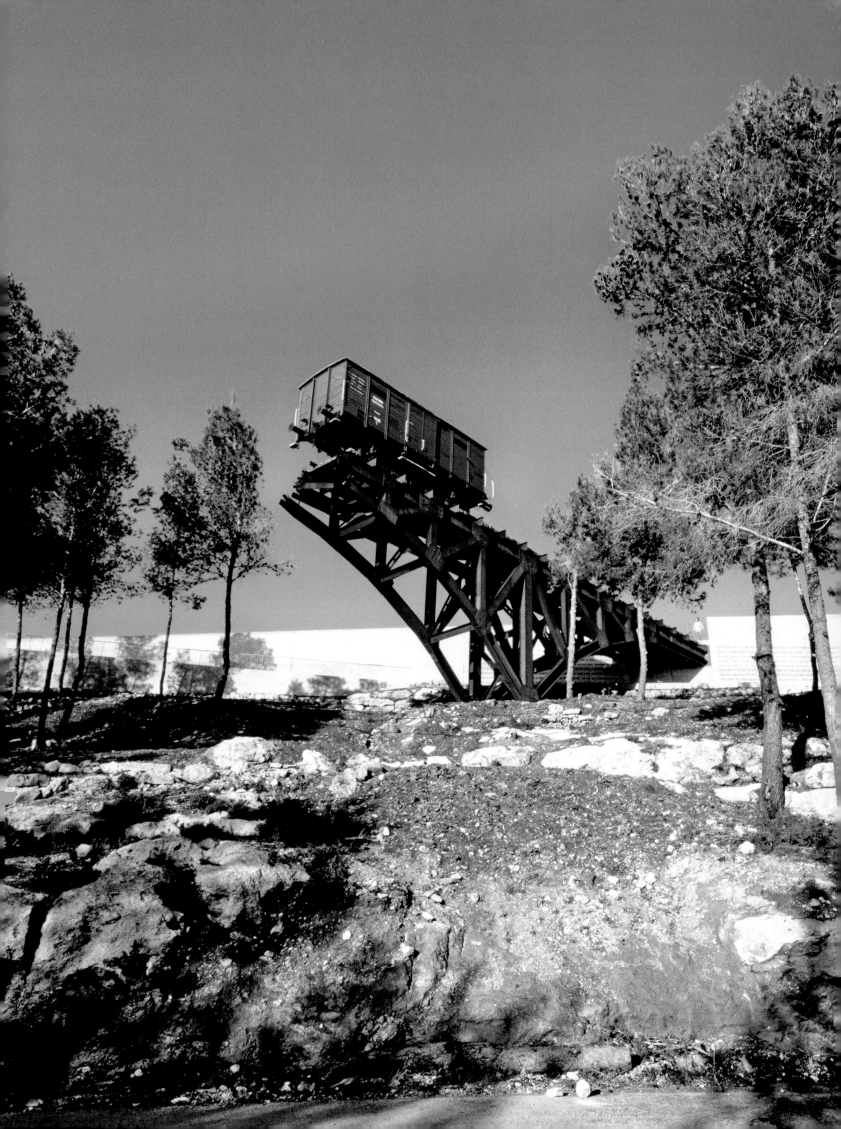

Children's Holocaust Memorial

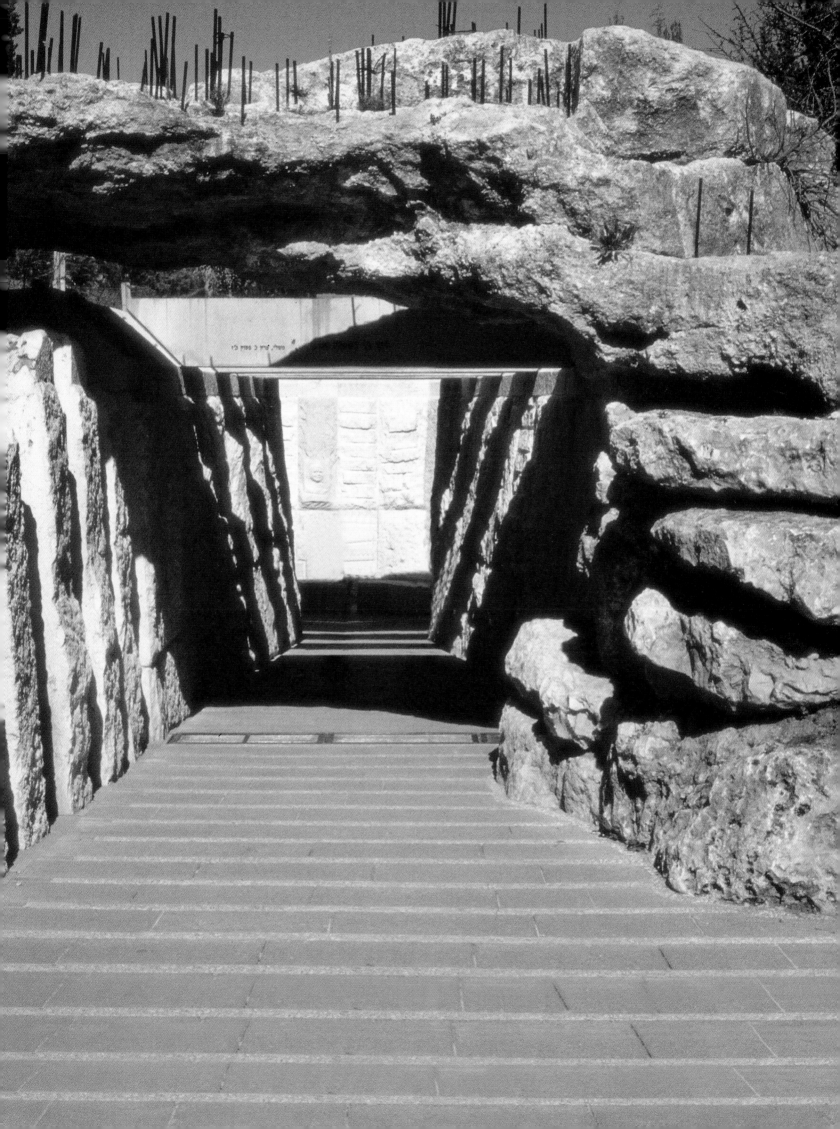

# Remembering

Elie Wiesel

The Holocaust History Museum at Yad Vashem, so brilliantly and meaningfully conceived by Moshe Safdie, is special in many ways. Because it is in Jerusalem?

A center of learning, a museum, and a remarkable sanctuary, it remains a great custodian of Jewish memory. It reminds the visitor of what a people, the Jewish people, endured in the middle of the twentieth century far away, in civilized Christian Europe. Whoever enters these walls and these pages will learn of its solitude, unparalleled in history, its suffering, its struggle for dignity and survival in hostile surroundings, in hopeless conditions. Here the biblical and timeless commandment "not to forget" will reverberate for generations to come.

Six decades after the horror-filled events, we realize that many if not all of those who were thrown into the world of darkness and death wanted above all to be remembered. At the end that's all they wanted. In some ghettos, and even in death camps, hundreds of inmates would join in conspiracy and self-sacrifice to enable one messenger to escape and bring the message of Treblinka and Auschwitz, always the same, to the free world. At the end their wish was no longer to live, but to survive and tell the tale. But that was not possible—the enemy was too cruel, too determined, too powerful, and the outside world too indifferent. To forget them would mean having them die again. Thus in this place, as in others, including the United States Holocaust Memorial Museum in Washington, D.C., extraordinary efforts are being made, at least, to record and remember their names, their stifled laments, their secret dreams, their tears, and even their agony.

Have we succeeded in truly transmitting their memories? Chroniclers and historians, survivors and witnesses, thankfully, have helped us become familiar with facts; have they properly been transfused into knowledge? We know WHAT happened; will we ever understand WHY it happened, and why to mainly one people? Granted, the enemy of the Jews was the enemy of mankind—but why have the children of Israel been chosen to be his first and implacable targets? Did we dream our dreams of fire and fear? It is not easy to remember too much; the threat of insanity is real. Not easy both to follow those nocturnal processions and not follow them. Not easy to vanquish despair. Ultimately, only those who were there know what

it meant being there. Others will never know. And it is not because we cannot explain that others don't understand; it is because others will not understand that we cannot explain.

I for one still encounter difficulties in finding the proper words. All seem pale, too weak. The name of the Tragedy itself seems inadequate: Is "Shoa" the right term? Or is "Holocaust" more appropriate? Is "Khourban," as Yiddish-speaking survivors would use in postwar Europe, better? Was it an attempt of the enemy to destroy our Third Temple? Is that why, in midrashic sources, it is described as a temple of fire? In truth, there are no words.

Also: When did the Tragedy begin? After Kristallnacht? At the outbreak of the war? During the first mass-murders of the Einsatzgruppen? When the first gas killings occurred? At the nefarious gathering in Wannsee? When more than a million children were sentenced to be shot, gassed, and burned?

Whenever we try to remember them we contain our tears. But *their* tears will forever reflect the ultimate limits of humanity. For the first time in recorded history, the systematic murder of Jews and the annihilation of their centuries'-old culture and tradition had been developed into state laws and scientific objectives. Some commentators call it "man's inhumanity to man." Was it not rather man's inhumanity to Jews? In the eyes of the cold-blooded murderers, Jews were condemned to die not because they were human, but because they were Jews.

And so, at times, as you walk through these pages, which reflect the exhibit, you see the pictures and read the documents inside Yad Vashem, and you get the strange impression that it was one SS man who murdered one Jew six million times. And yet each of the victims was unique.

What, then, are we to do with their memories? This is one of the many questions raised by many of us here and elsewhere; all remain unanswered.

In the domain of perpetrators, I still am perplexed: How could a nation known for its stunning achievements in culture and civilization allow itself to be a captive of leaders who turned hatred into strategy and religion? And why did it spread to so many lands in Europe?

More questions: Why didn't the liberation of death camps figure as a strategic goal in any military command among the Allied armies? Why did neither the Russians nor the Western Allies bomb the railways leading to Birkenau?

Why was Pope Pius XII silent? Why were there so few "Righteous Gentiles" to whom our people show the meaning of Jewish gratitude?

As for what took place inside ghettos and camps, the question is not why didn't they resist, but why so many of them *did* resist. The Jews had only a few weapons in their hands, but the Warsaw ghetto uprising in 1943 lasted longer than the powerful and well-equipped French army's defense of France in 1940. Where did Mordehai Anielewicz and his comrades find the audacity and the means to take up arms against what was then the mightiest military force in the world? All the underground movements received agents, money, and weapons from Moscow, London, and Washington; only the Jewish movement's pleas for help were ignored. Why? And where, near the flames of the ovens, did the most tragic of all witnesses, the members of the Sonderkommandos—the Dayan from Bendzin Reb Aryé Langfus or Zalman Gradowski—find the unbelievable strength to write their chronicles? At times one lacks the courage to read them; but if they were strong enough to write, we are duty bound to be strong enough to read.

Yet here you will also learn much of an aspect that has, for decades, been overshadowed by the horrors of the Tragedy: I refer to the survivors. Their tales are not only about suffering but about deep humanity and faith. Some prayed even there, others maintained their selflessness even there.

After liberation, how did they succeed to overcome incommensurate pain and anger and start building on the ruins?

In recent years, when hostages and prisoners of war have been freed, they have been welcomed by their nations with music, accolades, festive dinners, and official ceremonies. Not so the survivors. When some returned to their homes in certain Eastern European countries, they found them occupied by strangers or former neighbors…who angrily closed the door on them. In some cities they were taken off the train and massacred in broad daylight. Those who went to DP camps were

lucky. This is, also, what you will find in these pages, in this museum—and, in a broader context, in this land—a manifestation of Jewish solidarity and faith, and human greatness.

But this museum is dedicated to remembering both the tragedy and the heroism of our people in those dark years. "Shoa u'gvura," catastrophe and heroism. Is one term opposed to the other? I am not sure. I believe that somehow, in those times, those who died with weapons in their hands, and those who perished with prayers on their lips, had much in common: the martyrs were heroes and the heroes were martyrs.

And all we can do is think of the melancholy truth that they lived alone, prayed alone, despaired alone, fought alone, and died alone. Still, whether we know it or not, didn't something in all of us die with them?

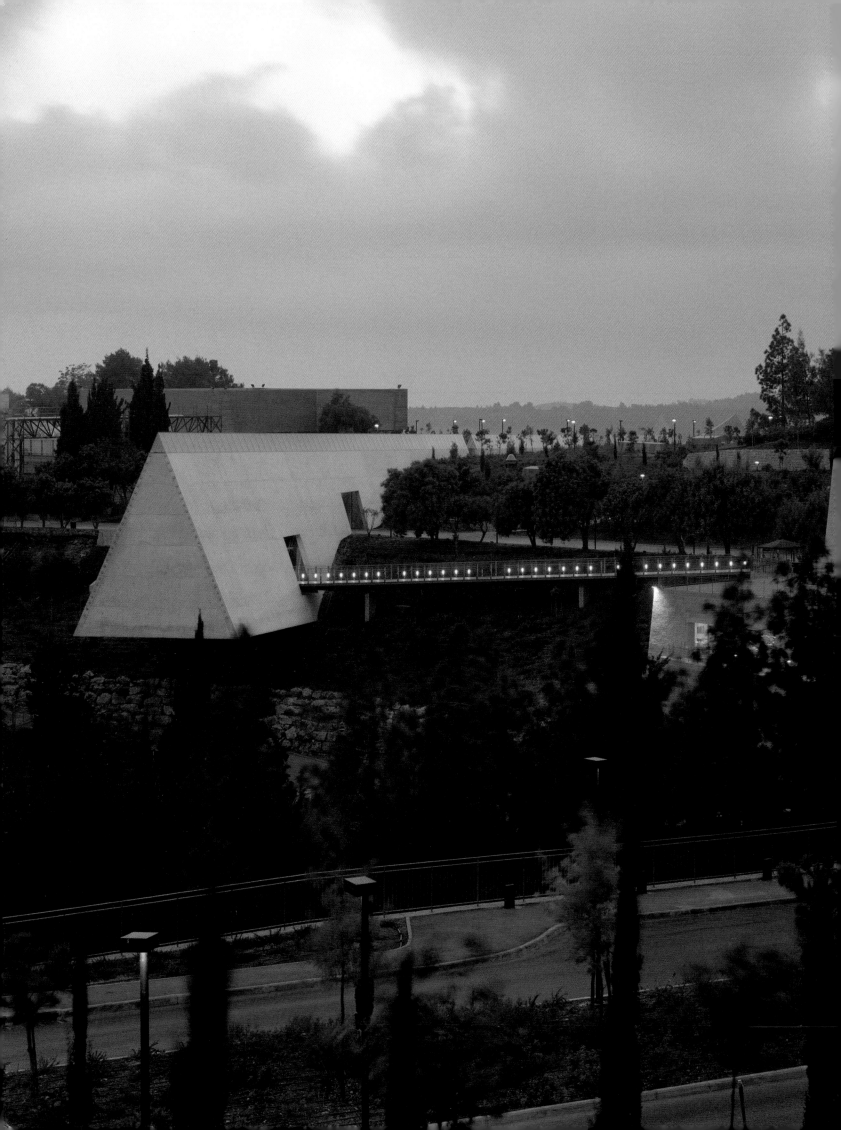

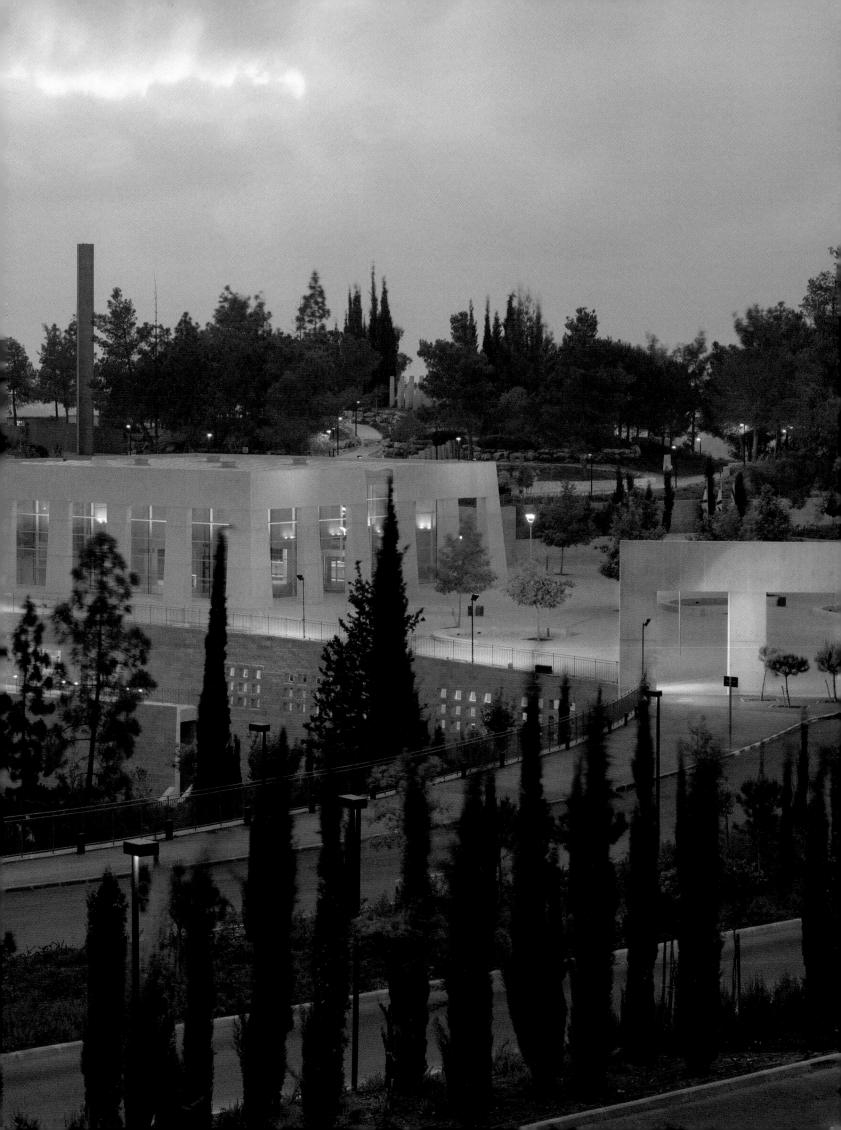

**Building Team Credits**

**Moshe Safdie and Associates:**
Moshe Safdie, Design Principal
Irit Kohavi, Project Manager
Gene Dyer, Project Architect
**Project Team:**
Paul Gross, Hugh Phillips, Leon Weizman, Dudi Tolkovsky,
Aliya Avery
**Project and Construction Managers:**
Tafnit Wind
**Landscape Architects:**
Shlomo Aronson Landscape Architects
**Exhibit Design:**
Dorit Harel Designers Ltd.
**General Contractor:**
Minrav Eng. & Building Ltd.
**Construction Management:**
Chaskelevitch Engineering Ltd.
**Mechanical Engineers:**
B. Schor Consulting Engineers Ltd.
**Electrical:**
Karl Valant; Etkin-Blum Electrical Engineers Ltd.
**Sanitary:**
A. Yosha Consulting Engineers Ltd.
**Structural Engineering:**
S. Ben Abraham Engineers Ltd.; Y. Gordon Engineers Ltd.
**Lighting:**
LAM Partners
**Museum Lighting:**
Topaz Electrical & Lighting Engineering Ltd.
**Glazing Systems:**
Landman Aluminum Ltd.
**Safety:**
Aldaag Engineers Consultants
**Acoustics:**
M.G. Acoustical Consultants
**Elevators:**
ESL—Simcha Lustig

**Exhibit Team Credits**

**Chief Curator:**
Avner Shalev, Chairman of the Directorate
**Curator in Charge:**
Yehudit Inbar, Director, Museums Division
**Historical Counsel:**
Prof. Israel Gutman
**Coordination of Building and Production:**
Ishai Amrami, Director General
**Senior Artifacts Curator:**
Haviva Peled-Carmeli
**Senior Art Curator:**
Yehudit Shendar
**Photograph and Film Curator:**
Nina Springer Aharoni
**Historical Research:**
Avraham Milgram
**Texts:**
Naama Galil
**Exhibit Design:**
Dorit Harel Designers Ltd.
**Film Production Coordination:**
Liat Benhabib
**Film Directors:**
Ayelet Heler, Reuven Hecker, Neomi Schory
**Film Production:**
Belfilms Ltd.
**Exhibition Production Manager:**
Orit Hall
**Exhibit Contractor:**
Galilee Furniture Ltd.
**Graphics Production:**
Yad Vashem Information and Communications Systems Division
**Media Contractor:**
Avitecture Ltd.; Barkai Benny Brookstein Ltd.

About the Contributors

Moshe Safdie, FAIA, CC, heads Moshe Safdie and Associates, an internationally renowned architecture and urban design firm based in Boston, with branch offices in Toronto and Jerusalem. Beginning with Habitat '67, his seminal experimental housing project constructed for the Montreal World's Fair, Safdie has contributed meaningfully to the development of many building types—museums, libraries, performing arts centers, government facilities, airports, and houses—and the realization of entire cities.

Safdie has served as director of urban design and Ian Woodner Professor of Architecture and Urban Design at the Harvard Graduate School of Design, in addition to teaching at various other universities. He is the author of several books on architecture and urban planning, most recently *The City After the Automobile*. Among the numerous awards he has received are the Companion Order of Canada and the Gold Medal of the Royal Canadian Institute of Architects.

Significant works include the National Gallery of Canada in Ottawa; the Exploration Place Science Center and Children's Museum in Wichita, Kansas; the Peabody Essex Museum in Salem, Massachusetts; the Salt Lake City Main Public Library in Salt Lake City, Utah; the Skirball Museum and Cultural Center in Los Angeles, California; the Khalsa Heritage Memorial Complex in Anandpur Sahib, Punjab, India; and the Ben Gurion Airport and the Yitzhak Rabin Center for Israel Studies, both in Tel Aviv, Israel.

Joan Ockman is the director of the Temple Hoyne Buell Center for the Study of American Architecture at Columbia University's Graduate School of Architecture, Planning and Preservation, where she also teaches architecture history and theory. Her most recent book, edited with Salomon Frausto, is *Architourism*.

Avner Shalev is the chairman of the Yad Vashem Directorate and chief curator of the Holocaust History Museum. Serving in the Israeli Defense Forces for many years, he reached the rank of brigadier general. After retiring as chief education officer of the IDF in 1980, Shalev acted as director of the culture and art division of the Ministry of Education and as chairman of the National Culture and Art Committee.

Elie Wiesel was awarded the Nobel Peace Prize in 1986. He is the Andrew W. Mellon Professor in the Humanities at Boston University. His most recent book is *The Time of the Uprooted*, a novel.

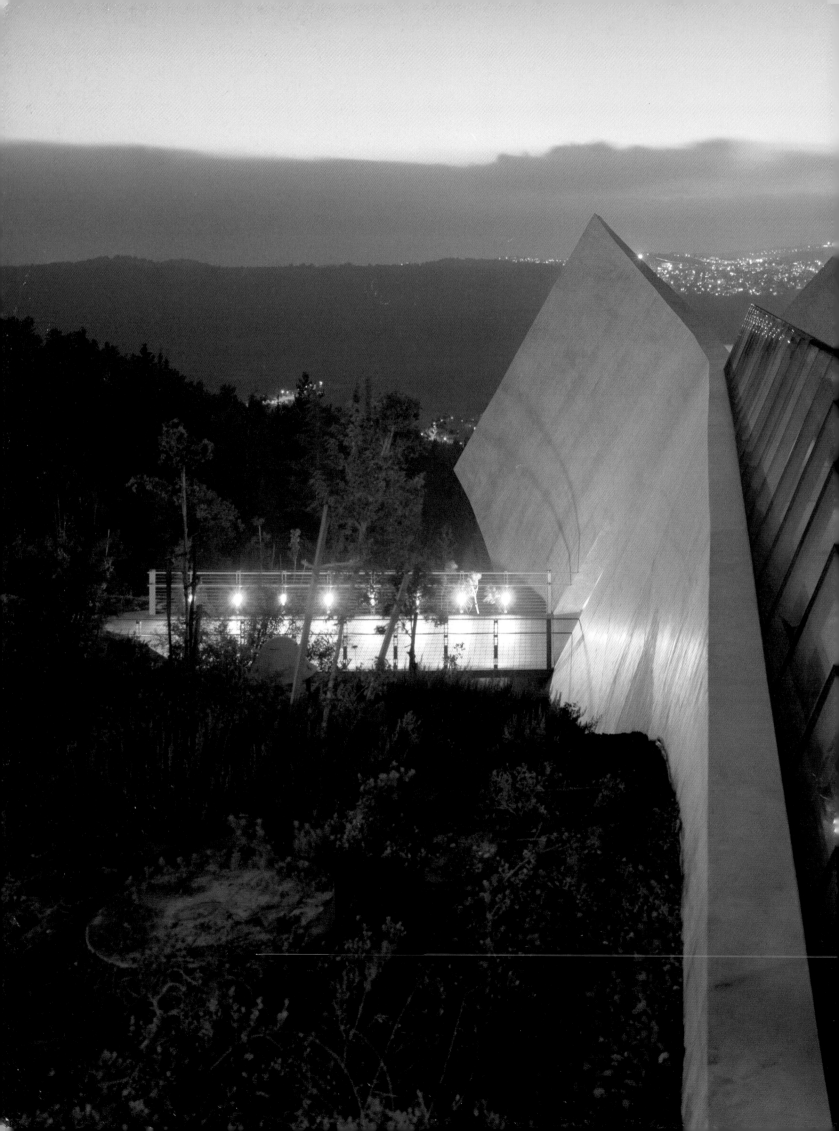

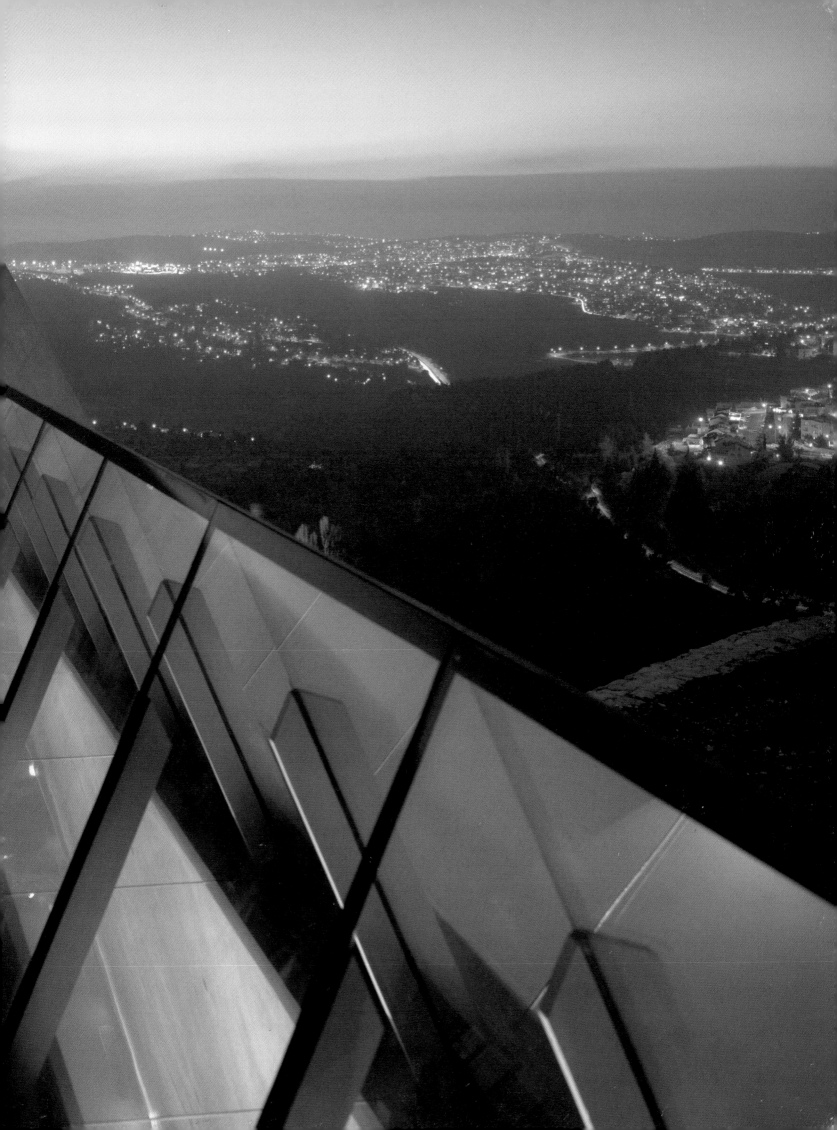

Yad Vashem
Moshe Safdie—The Architecture of Memory

Concept: Lars Müller, Moshe Safdie, and Diana Murphy
Text editing: Diana Murphy
Coordination: Laura Jackson
Proofreading: Claudia De Palma
Design: Lars Müller
Typography: Esther Schütz, Integral Lars Müller
Lithography: SRS Reproduktionen GmbH, Muggensturm, Germany
Printing: Konkordia GmbH, Bühl, Germany
Binding: Josef Spinner Grossbuchbinderei GmbH, Ottersweier,
Germany

Illustration Credits
Ardon Bar Hama: 15–17, 40, 46, 64–65, 80, 97, 110–11, 116–19
Yossi Ben David: 51, 53, 55–57, 59
Timothy Hursley: jacket front, 3, 8–15, 18, 27, 32–33, 35, 37, 43, 45,
66, 68, 70–73, 80, 81, 83, 85, 105–9, 112–15, 130–31, 134–35
Lars Müller: 76
Michal Ronnen Safdie: 38, 39, 41, 42, 44, 47–49, 67, 69, 71, 74, 75,
77–79, 82, 100, 121, 123–25
Moshe Safdie: sketches on 86–91, 102–3
Courtesy of Moshe Safdie and Associates: 95; presentation
drawings on 15, 28–31, 80, 119

Printed in Germany

ISBN 13: 978-3-03778-070-1
ISBN 10: 3-03778-070-3

Lars Müller Publishers
5400 Baden, Switzerland
www.lars-muller-publishers.com

Published with a generous grant from

BANQUE SAFDIÉ
Genève, Zurich e Lugano